# The
# iPhone
# PHOTOGRAPHER

## *How to Take Professional Photographs with Your iPhone*

### Michael Fagans

AMHERST MEDIA, INC. ■ BUFFALO, NY

**Michael Fagans** enjoys telling people's stories. His journey has taken him to the Navajo Nation, Malawi, India, Afghanistan, Scotland, Canada, the Dominican Republic, Belize, and Guatemala. He graduated from the Rochester Institute of Technology's College of Imaging Arts and Sciences and was the National Press Photographers Association's 2005 Photographer of the Year for New York state and Ontario and Quebec provinces. His photography clients include The Center for Investigative Reporting, United Way of Kern County, Epigraph Records, Kern Food Policy Council, *The New York Times*, and the *National Journal*. Fagans is also a former assistant photo editor at *The Bakersfield Californian*, where he focused on multimedia, video, and web projects for the photo staff, curated the SEEN page, and worked with the front-page designer. Currently, Michael is the Director of Strategic Communication for the United Way of Kern County, helping nonprofits inform their clients, volunteers, and the community about the work they are doing. This may include still photography, video, web projects, social media, or a combination of media. Fagans is a founding member of risingtideproductions.tv. In 2013, the group had a short film screened in the "Outside the Box" Bakersfield Film Festival.

Copyright © 2015 by Michael Fagans.
All rights reserved.
All photographs by the author unless otherwise noted.

Published by:
Amherst Media, Inc.
P.O. Box 586
Buffalo, N.Y. 14226
Fax: 716-874-4508
www.AmherstMedia.com

Publisher: Craig Alesse
Senior Editor/Production Manager: Michelle Perkins
Editors: Barbara A. Lynch-Johnt, Harvey Goldstein, Beth Alesse
Associate Publisher: Kate Neaverth
Editorial Assistance from: Carey A. Miller, Sally Jarzab, John S. Loder
Business Manager: Adam Richards
Warehouse and Fulfillment Manager: Roger Singo

ISBN-13: 978-1-60895-887-0
Library of Congress Control Number: 2014955648
Printed in the United States of America.
10 9 8 7 6 5 4 3 2 1

**Check out Amherst Media's blogs at:** http://portrait-photographer.blogspot.com/
http://weddingphotographer-amherstmedia.blogspot.com/

# Contents

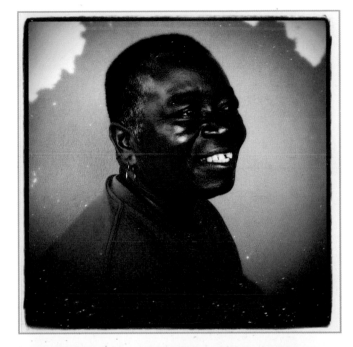

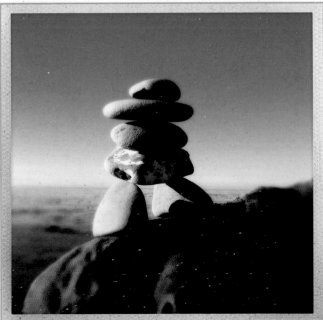

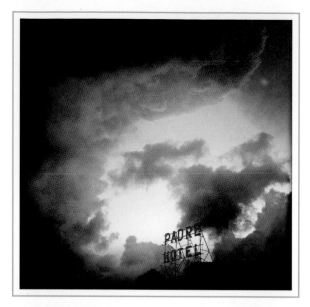

# Introduction

This is a book about using a camera phone and apps to make what, I hope, are interesting photographs. Along with some technical information that I know folks will want, I've included a lot of information about my mind-set when shooting, my approach to composition, and how I handle other creative aspects of the photography process.

## Re-Invent Your Image-Making

I have been thinking about making images for a long time. I can probably trace my love of image-making as far back as the fourth grade, when a Pentax K1000 showed up in my life. I used it on and off for years. I went on to learn film processing and print making at the Appel Farm Arts and Music Camp. But eventually, I forgot that part of my life—only to rediscover it much later.

The big breakthrough in my life, career, and (at that point) hobby came when I realized that I related to people through my photography— by showing them the images and talking about my experiences in life. It happened slowly over time, but when the realization crystallized in my mind, it was time to pursue becoming a professional. That's something I've now been doing for over fifteen years.

Shooting with your phone is another kind of breakthrough or creative reinvention. Because of its limited controls, shooting with a phone requires you to strip down your process to the fundamentals. To me, that's the great thing about it—it forces you to use the best part of the process: your brain. For me, using my iPhone has helped me reconnect to my craft, something commerce had clouded in my head. And so now I have thousands of pictures on my phone, because that's what I do. *I take pictures.*

## About the Quotes

In each section of this book, you'll find a yellow box containing a quote intended to go with the image. The quote may say more in one sentence than I do with many; it is your choice to read both, one, or none.

## Paying It Forward

Many people have helped me get to where I am today; a number of them are mentioned throughout this text. In this book, I've tried to live up to my responsibility to share what I have learned and to provide some insight to others. I am just paying my mentors back by paying it forward.

# 1. Mother and Daughter

This image *(facing page)* is one of the earlier ones I made with my iPhone. There are a number of things working in the image, particularly the mirrored behavior of mother and daughter. What this portrait reminds me is that, many times, allowing our subjects to forget that we are there can be very productive.

### The Hipstamatic App

Hipstamatic is a fairly simple app and creates a square format I haven't used since shooting with a Hasselblad in college.

Why is the Hipstamatic app so interesting to me as a professional photographer? The answer, I believe, is that it is fun to make images with my iPhone. Also, I almost always have my iPhone with me, so my chances of making an image are greatly increased. There is something to be said for stripping photography down to the very simple and making images. There are limitations to the iPhone that force me to think creatively—as does shooting in the square

▲ The Hipstamatic app.

format. At the end of the day, it helps reconnect me to the joy of making photographs. And that may be all the difference.

In this quiet image, the app's Blanko film and John S lens settings produced muted colors that are well suited to the downcast faces of my subjects.

### A Digital Simulacrum

The other interesting and enjoyable thing about shooting with the Hipstamatic app is that it offers a digital simulacrum of the plastic Holga camera that I still have in my gear

▼ Additional images of the same subjects.

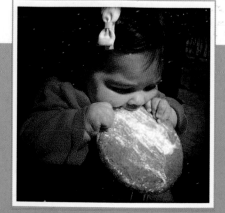

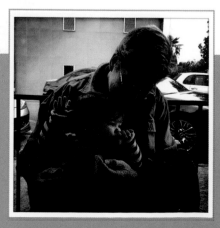

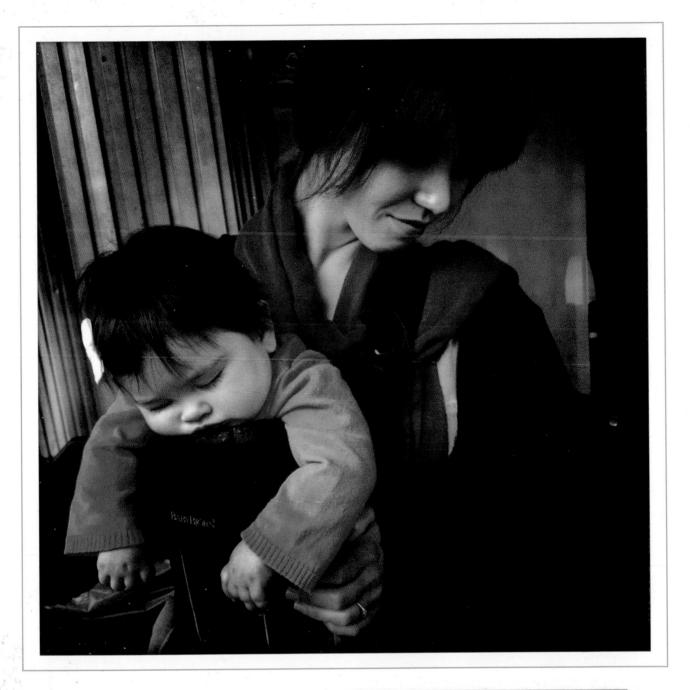

closet. Many of us fondly recall our first plastic camera—taping it up to prevent light leaks, threading the medium format film in, and then using the incredibly inaccurate focusing guide showing one person, a group, and then the mountains.

"The camera is an instrument that teaches people how to see without a camera." —Dorothea Lange

# 2. A Simple Portrait

The really good photographs ask the simple, central questions in life. Who are we? Where did we come from? And why are we here? I'm not sure that an image can ever fully provide answers—sorry, it's the truth—but there are times when a simple portrait says more about a subject than words ever could.

## Lighting and Design

Meet my friend Doug Bennett, whose larger-than-life story is writ large in his face and on his body *(facing page)*. What I really like about this image is the subtle expression on his face that conveys so much about the kind of person he is. People who know him will wonder how I managed to get him to sit still for this portrait.

This photograph is side lit by afternoon window light from camera left. What initially caught my eye was the pattern of repeating black and white horizontal lines in the background and the realization that they matched Doug's shirt—he almost always wears black, but that is a story for another time.

## Subject

It is important for our subjects, even our friends, to be comfortable with the photographer, the camera, and our intentions. When people can relax and be themselves, the viewer starts to get a glimpse of one or many aspects of who the subject is in life. The first time Doug and I really worked together, we had one of those moments that cements a relationship and informs both people about where they align ethically. I think (or at least hope) that Doug was able to settle into this pose comfortably because he trusted the person on the other side of the camera.

▼ Portraits don't need to be complex to say a lot about the subject of the image.

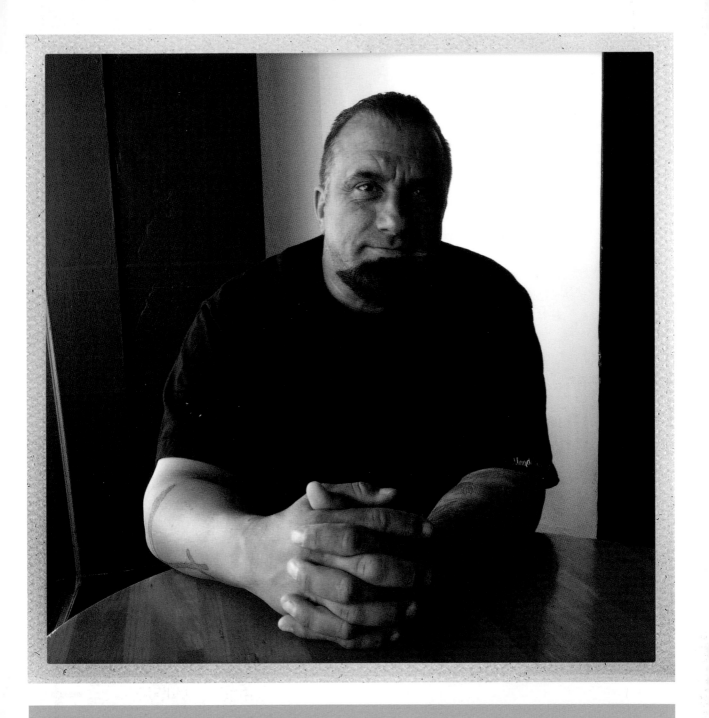

"What's really important is to simplify. The work of most photographers would be improved immensely if they could do one thing: get rid of the extraneous. If you strive for simplicity, you are more likely to reach the viewer. " – William Albert Allard

# 3. Fiber Artist

It can be fun to photograph other artists. In this image, a friend of mine who primarily crochets with yarn posed for a photograph at a locally owned coffee shop in our town.

## Instagram and Filterstorm Apps

Unusually for me, I shot this image using the iPhone's camera function. I then cropped and toned it in Instagram. I love the full-frame "burned edge" look in Instagram. I blame it on many years in the darkrooms at the Rochester Institute of Technology printing in black & white with a full-frame holder in my enlarger!

Now I can just click a button, but it reminds me of the visceral experience and effort it once took to get this look. Of course, the border is also functional in framing the image when viewing it backlit on an LCD screen or phone.

The Lo-Fi filter in Instagram tends to blow out highlights, so I take many images through the Filterstorm app to lower the midpoint of my S curve prior to importing them into Instagram. That being said, the photographer is now able to control the amount of Lo-Fi and other filters applied within Instagram itself, but the thought process and technique still hold up.

◄ Adjusting midpoint in Firestorm.

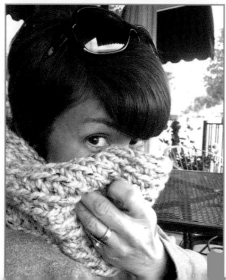

◄ The original, unedited image capture.

## Hipstamatic

In the Hipstamatic app, with the swipe of a finger I can change my film and my lens settings to whatever combination I find works with the subject matter at hand. You can also save your favorites so they appear at the top of the menu. For example, I have the Lowy lens at the top, followed by Loftus, Jane, Tinto 1884, and John S. On the film side of things, my top pick at the moment is Blanko BL4, followed by W40, Ina's 1982, C and D-Type Plates, Blanko C16, and Sussex. I have also disabled the "shake the camera to change lens and film combinations" feature, but that is up to you. There are days I like to add a little randomness into my life – but not here.

Ina's 1982

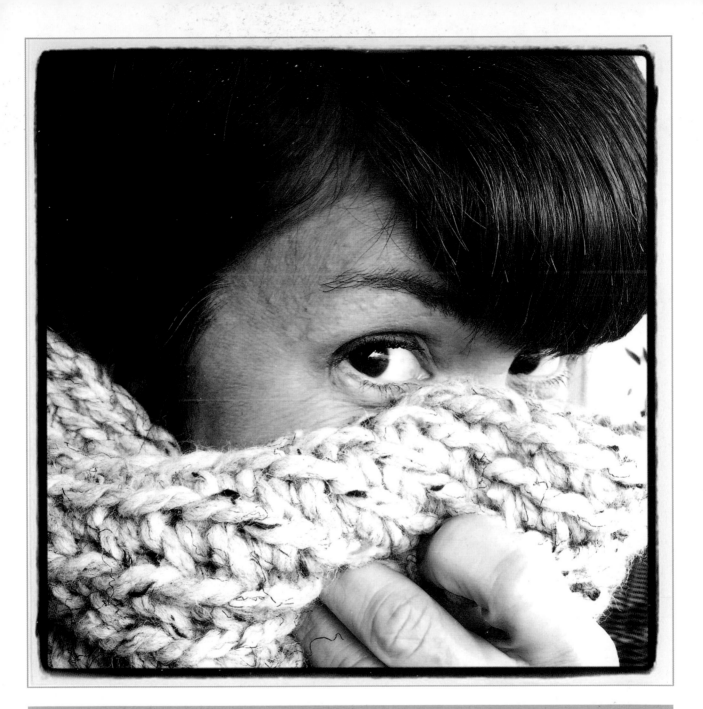

"It's often about the simple things, isn't it? Painting and Instagram are first about seeing, they say. Writing is about observing. Technique is secondary. Sometimes the simple is the most difficult." – Linda Olsson

# 4. Village Medicine Man & Family

The Hipstamatic Jane lens and Ina's 1982 film became my "standard" settings over time, and eventually even that merged into the Lowy lens and Ina's 1982 because they created the least distortion and truest reproduction of what my eye saw in the moment.

## Lighting and Posing

In this photograph, shot in a Mayan village in the southern part of Belize, a village medicine man posed with two of his children as a storm moved into the forest. The sunset created a nice softbox effect. The direct eye contact with the children juxtaposes well with the central subject staring off out of the frame—or into the future? When the light, subject, and contributing background are working well, I don't want to overly process things with the camera or the app. That is when I go to my standard setting and get out of the way of the picture making.

## Testing

I suggest running a camera test with your app and settings—just like you would with a new camera or lens. I do this by photographing

> "Life is like photography. You need the negatives to develop." – Ziad K. Abdelnour

in the same situation with as many lens and film setting combinations as I feel like sussing out after the shoot. In the Prints section of Hipstamatic, there is a handy record of the film and lens choices used. (I'd like that data to show up in Photoshop's File Info, but it *is* visible in Adobe Bridge CC's metadata under File Properties > Application.)

Running some tests should help you find what combinations are pleasing to your eye and then learn what situations call for different settings. That second step may take longer, so I am fully in favor of experimenting in the field. Here's a bit of advice I give my students and interns: If you are stuck, shoot everything in your bag. For photographers using DSLRs, that means use every lens—even if you think it is the "wrong one" for that situation. Getting a different perspective can sometimes jog our brains into working better or more critically.

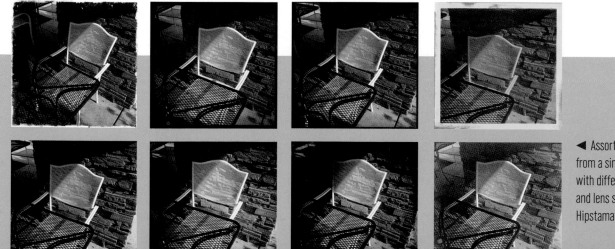

◄ Assorted images from a simple test with different film and lens settings in Hipstamatic.

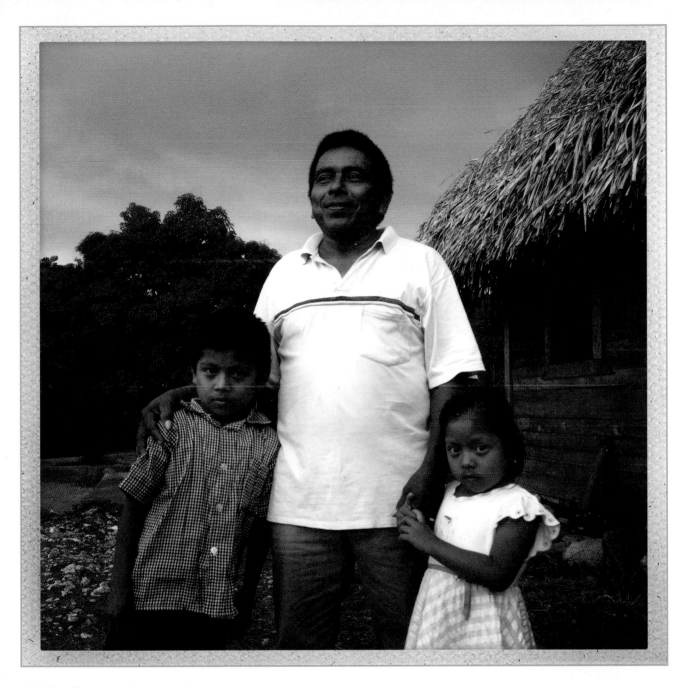

▼ Additional images from the same session.

# 5. Try Shooting a Series

All too often, in the newspaper business, you only get a few minutes or an hour to work with someone and then you are off to another assignment. That is fine for putting out a daily publication, but it doesn't start to get at discovering a slice of who someone really is. Over time, and with experience, I have realized that making one portrait of someone and then moving on to make another portrait of someone else is not the most effective way to create images.

## Moods and Moments

As I photograph my family, I have begun to realize that only a series of photographs can truly capture the essence of my loved ones and friends. Capturing them in different moods and unique moments really starts to illustrate

> "We are often taught to look for the beauty in all things, so in finding it, the layman asks the philosopher, while the philosopher asks the photographer." – Criss Jami

and illumine who they are. So, I keep making pictures, waiting for glimpses of the person beneath the mask that we present to the world.

## Refining Your Approach

It can be frustrating to think about producing "definitive" portraits of someone. Instead, I try to study how other photographers make

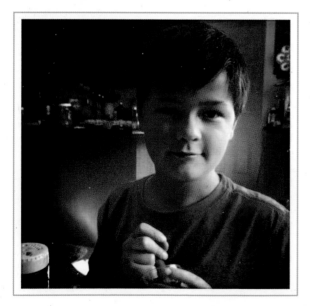

interesting portraits or use new techniques to help make people feel comfortable. And I really try to remember how *uncomfortable* you can make someone feel by pointing a camera at them.

## Rules Are Made to Be Broken

Too often in photography, people get caught up in trying to make or create or find the perfect image—rather than working with what is in front of them. I often use a quote from the movie *The Pirates of the Caribbean* to explain my approach to the "rules" of photographic composition. (And yes, I am realizing that I may have to update my example in the near future!) In the movie, pirate captain Hector Barbossa explains the Pirate Code to heroine Elizabeth Swan, saying, "The Code is more what you'd call guidelines than actual rules."

Why is the concept of *guidelines* far more helpful than *rules*? The most obvious reason is that some people get really trapped in trying to adhere to the rules. This is another benefit of shooting with your iPhone. I find it is much easier for me to ignore, bend, and break guidelines as I shoot and edit within the frame of the camera phone.

At the end of the day, photographers should evaluate what is in front of them and what they can do with the subject matter and the lighting to make an interesting picture. Rules be damned! If you need some inspiration, the *National Geographic* website has an entire photo gallery about "Breaking the Rules."

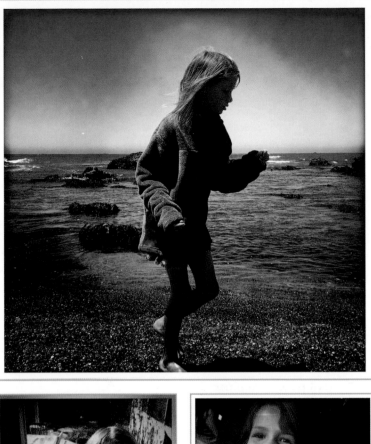

66 At the end of the day, photographers should evaluate what is in front of them and what they can do with the subject matter and the lighting to make an interesting picture. 99

# 6. Mission Portrait

My friend Brandon gets me into a number of interesting projects year to year—often more than once a year, if the truth be told. I'm not sure I've ever said no to any of his ideas or requests, so I don't think that I have any room to complain.

## Holiday Portraits

On this occasion, Brandon asked me to help him photograph clients at The Mission. He was assembling a team of makeup people and photographers to help folks look their best and then have a holiday (Christmas) photo taken to give to their families.

On a Friday, we assembled our group and looked at the space we had to work with: industrial brick walls and fluorescent lighting—everyone's favorites. It became readily apparent that our one Christmas set was not going to be enough, so a number of photographers volunteered to take individuals and groups out on the grounds to do outside portraits in addition to inside work.

## Colorful Characters

Right after we got Brandon's softbox erected, these two ladies emerged from hair and makeup in time for us to test and set the lighting levels. It is obvious that one of them is a character— and that her friend was *not* in a festive mood. Talking to them, it become clear that this was a difficult time for both. I have always been amazed by people who make the most of every

day and moment, and this situation was no different. Still, an "everything is great!" portrait would not have shown the true situation.

After some test shots to get the lighting and camera settings squared away for Brandon, our exuberant friend jumped in the back of her friend's portrait—and something close to the truth emerged. In the midst of joy and recovery, there was still pain and sorrow. It is not as obvious as the theater masks with tragedy and comedy, thankfully; it is more subtle. In Hipstamatic, I shot the image with the John S lens and Blanko film settings.

### Two Sides of the Same Experience

Volunteering let me get to know some people in our community I might not have talked to that day. While I enjoyed the attempt to bring something new and different into someone else's life, I am fairly sure that my own life was more touched and changed for the better through our interaction. The gift I was able to provide that day was my time, my attention, and my craft to folks who might only have worked with a photographer in negative ways. So, I believe the portrait of two friends works because it illustrates two sides of the same experience.

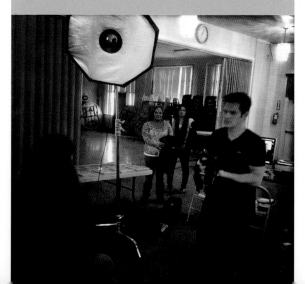

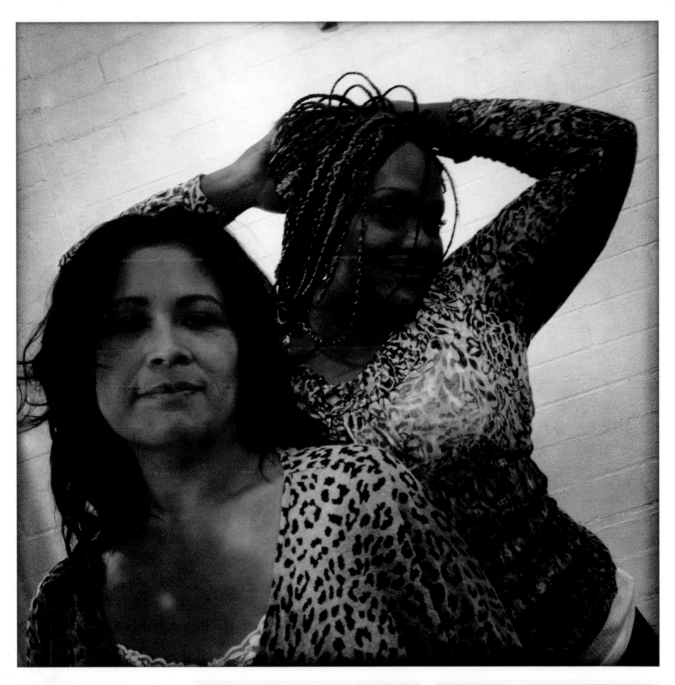

"Taking pictures is savoring life intensely, every hundredth of a second." —Marc Riboud

▶ Additional images from the same session.

# 7. Barista

I really enjoy a good cup of coffee, even though I get ribbed for preferring mochas. During a meeting with friends near LAX, I was telling them about my favorite coffee shop in Venice Beach and how we should go there for a cuppa. Folks agreed (primarily, I believe, because the beach was nearby). One person in particular, Reginald, observed that, "You must really like their coffee." After battling traffic for a while, we made it to Intelligencia and got our orders. I looked over at Reggie and asked him if it was

worth the drive. He smiled over the rim of his cup and nodded yes.

## Matching the Mood

One of the things I enjoy about the Hipstamatic app is dialing in the film setting to suit the location where I am taking pictures. As the company has added different looks, I've gained more latitude to capture what I see in front of me and interpret it in my own way. Initially, I started out shooting this scene with the Blanko film setting but felt that it was too cool with

## A Perfect Cup

You may, in the course of this book, get the idea that I go to a few coffee shops on my travels. I do. I completely blame my wife Deborah for getting me on this road, although I have had encouragement from John Harte, Felix Adamo, and other photographers!

▼ Additional images from Intelligencia, with two different Hipstamatic settings.

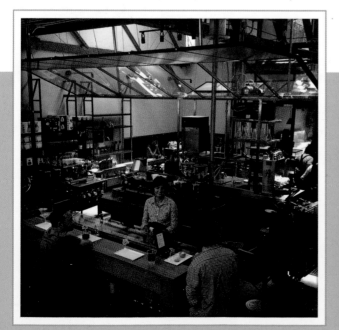

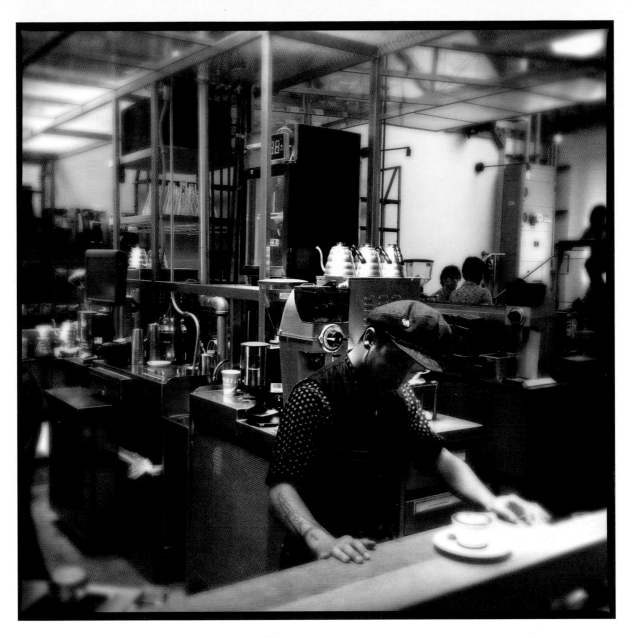

the light coming into the Intelligencia Coffee Shop from the skylights. After switching to the DC film setting with the Loftus lens, it became a matter of waiting for the right moment or gesture as I made photographs.

▲ The grid created by the metal in the shop adds a graphic quality that is balanced by the people in the space. This was just a quiet moment in the bustle of the store when the barista paused and looked down.

### The Right Moment

In this photograph *(above)*, I followed many of the traditional guidelines for making a good portrait. I let the barista do his thing and be himself. Since this isn't a formal portrait, there was nothing to direct—I was just waiting and observing. The environmental details helped tell the story and set the scene.

# 8. Women's Cooperative

What I like best about this image *(facing page)* is that I was able to get the look of a large-format camera while using an iPhone. My subject was much more relaxed than if I had used all of my professional gear!

## Background

The Sandy Beach Women's Cooperative in Belize was founded in 1986 and has come back from two suspicious fires, in 2003 and 2005, that forced them to rebuild their restaurant and guest buildings. Despite these setbacks, the group is going strong and provides jobs for twenty women in the community. They recently hosted a Peace Corps volunteers meeting and are looking to establish a conference center in the future. They are just a remarkable group of women who are trying to earn a living and support their families—and they cook some amazing food! I have never left hungry.

I think you can see the pride of ownership in this portrait. I can write about techniques

"If Rembrandt had been given a camera, then that guy's understanding of light and form would have blown the rest of us shooters into a black hole of despair." – Steve Merrick

and tools, but at the end of the day, the image should still be about the subject. One of the things I like about multiple visits with the same groups is that we are able to establish relationships. (There is one man in particular who shows up every time we visit here—and I can almost predict what he will say word for word. I still enjoy talking with him.)

The really sweet moments are when we are done visiting and can just sit down on the porch of their restaurant and enjoy a beverage and visit with each other.

◄ Additional images from the Sandy Beach Women's Cooperative.

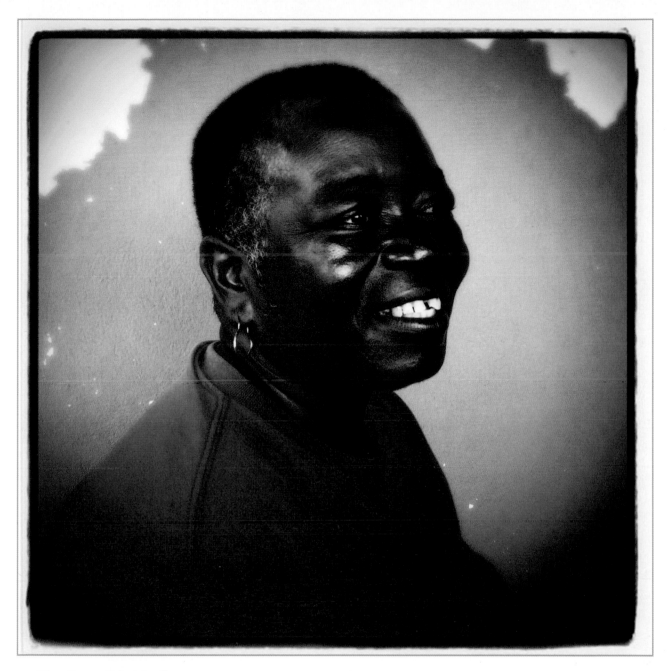

## Shooting and Production

I shot this image with Hipstamatic's Loftus lens and W40 film settings. I did minimal preparation in Filterstorm and then used Instagram's Lo-Fi filter and a border effect. The color saturation works well, with the wall contributing a nice color wash to give the image a tropical vibe. The vignetting from the Lo-Fi filter also helps brings your eyes back to her amazing face and smile.

The relationship between the orange and green, almost complementary colors, helps explain why the image is attractive to our eyes. The spots of pale blue in the top corners of the frame offset some of the potentially strong Christmas color effect.

# 9. **Brandon**

### Selective Stylization

If I remember correctly, when I shot this image *(facing page)* the C- and D-Type plate film settings and Tinto 1884 lens had just been released by Hipstamatic and I was using them quite a bit, trying to see how far I could push them and the phone camera. Like any new toy, the combination was bright and shiny—but there is a time and place when they work well and it's important to recognize when they don't and change things accordingly. For example, I have found that the Tinto lens often softens the photograph more than I like—and it's center-weighted so that what is in the middle is in focus, even if I recompose the image.

In this case, though, the image is successful because of the film and lens combination. I know that this is a photography "geek" image for those of us who wish we were shooting on daguerreotype plates. I use the combination sparingly because I think it can very quickly become a cliché. Still, I am amazed that the iPhone and apps can create an image like this—without any messy chemistry!

> "A portrait is not a likeness. The moment an emotion or fact is transformed into a photograph it is no longer a fact but an opinion. There is no such thing as inaccuracy in a photograph. All photographs are accurate. None of them is the truth."
>
> – Richard Avedon

▼ Additional images from the same session.

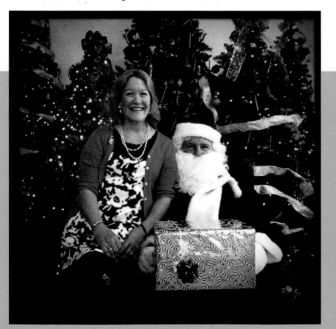

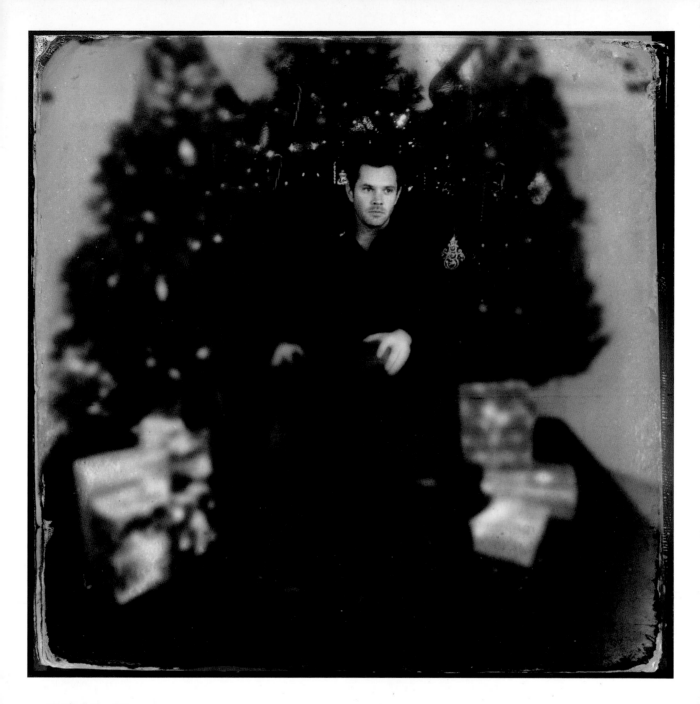

## Behind the Scenes

Checking out the introspective look on Brandon's face, I start wondering why he didn't look more overjoyed in the festive setting—and what he might be thinking about. On this day, we set up several stations where people could have their portraits taken with Santa or some elves. After much wrangling of lights, trees, extension cords, printers, and lighting gear, we finally had a moment to catch our breath. I believe that is when Brandon sat down to take a break and I made this photograph. We had an entire team working with us that day, including a number of volunteer photographers.

# 10. Guatemala

I traveled to Guatemala to help my friend Brandon and his B.Love.co company distribute jeans and shoes at a school in Chimaltenango.

## A Meaningful Trip

The parents of the children who go to this school work in the giant garbage dump nearby, collecting and scavenging from the trash. Brandon's company donates a pair of jeans overseas for every pair purchased in the United States. It is a fascinating project and company, so I was glad I could help out.

There were a number of things that were probably lost in translation that day. The children might not have fully grasped what was going on or why the clothes and shoes were being given to them—but I am fine with that.

What was meaningful for me is that I was able to be there and support a friend during an important time in his life and ministry.

## Shooting and Composition

I just love the three little ladies (*facing page*). The different expressions on their faces, their body language, the holding of hands and the crossed arms—it just warms my heart. I am a big fan of threes, so this photo works on that level, too. I like that one of the three girls is sitting, while the other two are standing, that one of three does not have shoes, and the repetition of the pairs of jeans held on everyone's left side.

With the Hipstamatic app, I shot using the Jane lens and the Ina's 1982 film settings. In Instagram, I applied the Lo-Fi filter.

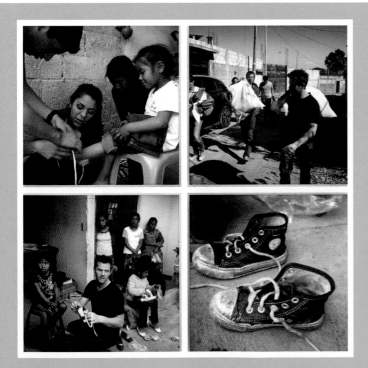

## An Emotional Day

This was an emotional day for Brandon because he was distributing clothes for the first time. One of the other special things about his business model is that each article of clothing has a unique number so things can be tracked, allowing people who purchase clothing and shoes to see exactly what village the clothing is donated to. The crew decided to wash the children's feet before sizing them for two reasons. One was practical – it was easier to size the shoes and more hygienic for the person trying on the shoes (or whoever might be trying them on afterward). The other reason is based in faith. The symbolic act of washing these feet was very meaningful for him and echoed what he is called to do and be as a Christian. The trouble for me? The foot washing was really difficult to photograph with either my iPhone or my DSLR!

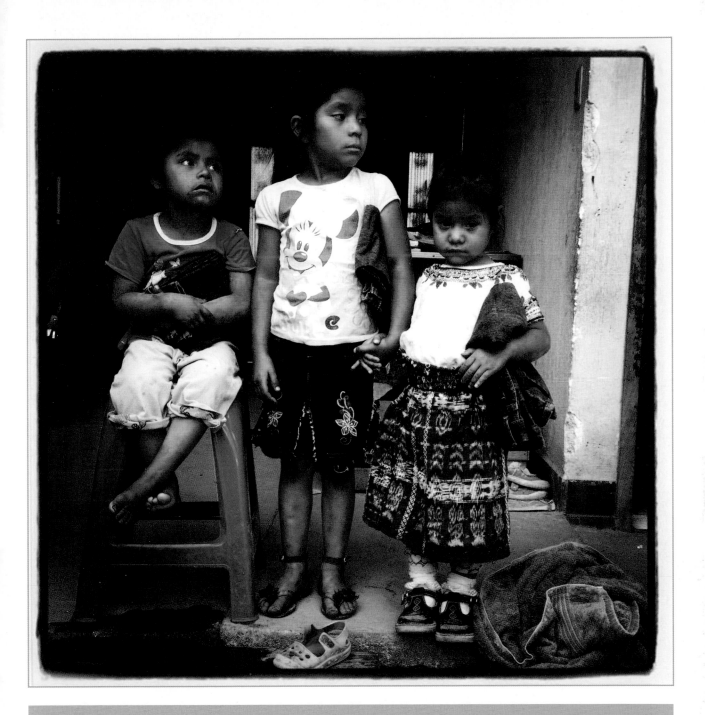

"My pictures are about making people realize we've got to protect those who can't speak for themselves." — Michael "Nick" Nichols

# 11. Self-Portrait

There are arguments to be made for and against selfies—and while I try not to make too many self-portraits, I do take them from time to time. One of the more talented young photographers in our town did a year-long series of self-portraits that was actually very interesting and insightful, so I know there is a place for the form.

### Concept and Composition

What makes my selection *(facing page)* work for me are the smaller mirrors arranged around the center mirror, giving different variations on my reflection. I really like the zoetrope effect that the smaller mirrors create. As I look around the

circle, it is like my still image is moving around. I also like the symmetry in the picture (even in the lights behind me in the hallway). The spot color of the red from the carpet also works to balance the yellow from the walls. All in all, there is a lot to pull the eye around the frame—and many things to discover when looking at the image for a second or third time.

### Processing

I shot with the Hipstamatic app, using the Lowy lens and Ina's 1982 film settings. I went with the Hudson filter in Instagram to work with the color cast from the fluorescent lights in the hotel where I was making the picture.

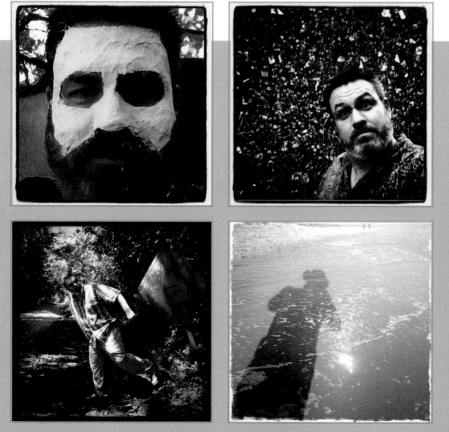

### For Comedic Effect

From these images, you can see that I generally go for the silly or funny in my selfies – be it posing in front of a wall of gum or pretending to be chased by jaguars. I am not sure how to categorize the mask image, so I will leave that in your capable hands.

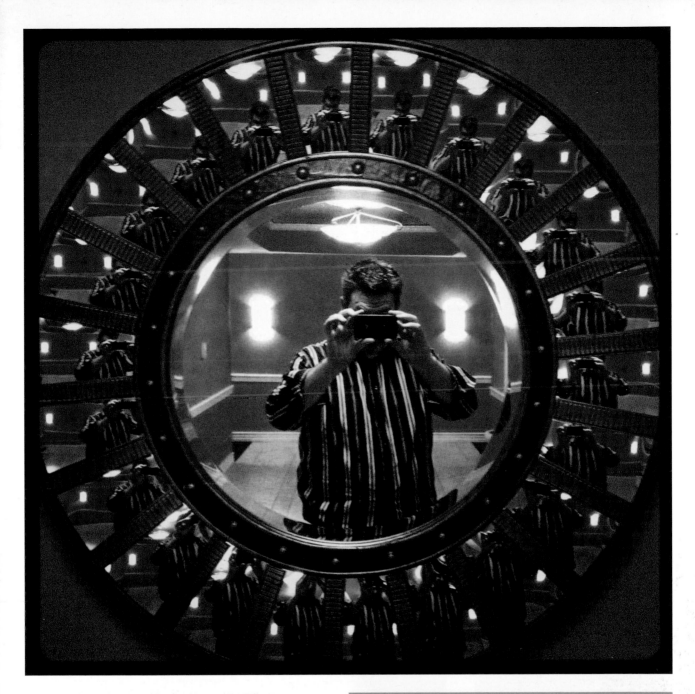

I tried working with the image in Filterstorm, but I really could not do much there, primarily because of the fluorescent lighting in the hotel hallway. I was also on my way to a meeting; this was a quick edit in the elevator so I could post it to Instagram before things started up!

"Stare. It is the way to educate your eye, and more. Stare, pry, listen, eavesdrop. Die knowing something. You are not here long."

– Walker Evans

# 12. Flowers

nother subject that photographers seem to be attracted to would have to be flowers. We could talk about their impermanence, the play of light on their variable surfaces, romance, nature, and the simple joy of the color they bring to our lives.

## A Farmers' Market Find

I have purchased a lot of flowers in the year since our foster daughter moved into our lives. For several months, she would spend her allowance at the farmers' market on flowers that she would keep in her room. She learned how to bargain with the stand owner, to negotiate with me (when the flowers cost more than she had left after buying a cookie), and to determine what might last longest in her room.

> "The camera has always been a guide, and it's allowed me to see things and focus on things that maybe an average person wouldn't even notice."
>
> – Don Chadwick

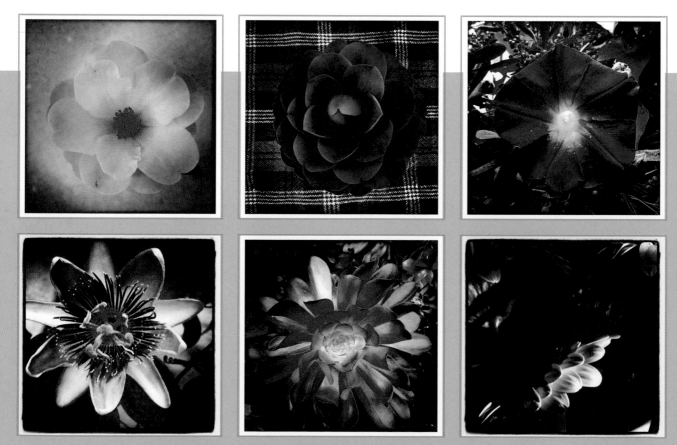

▲ Some additional flower images, including a succulent found on the coast, morning glories from our front yard, and flowers from our foster daughter's room lit by beautiful afternoon sunlight. In each situation, I try to get out of the way as a photographer and just let the flower tell its story.

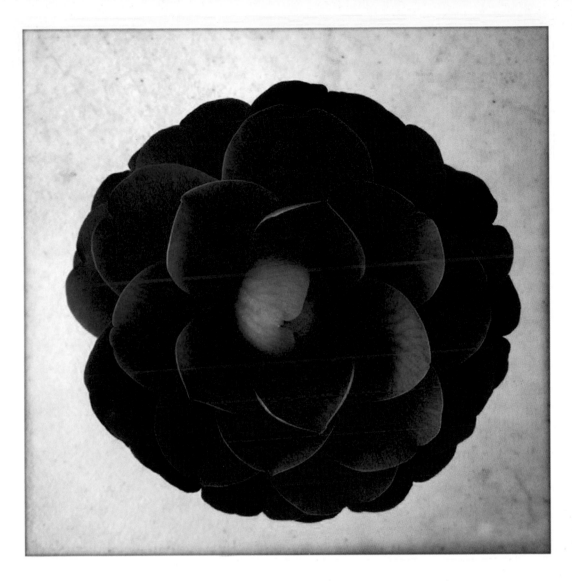

We seemed to have finally found a flower that worked well—just in time for her attention to turn elsewhere.

## Lighting and Composition

I like the simple composition of this flower (*above*) from the farmers' market. The red blossom, placed in a simple plastic cup, contrasts beautifully with the plastic table behind it. It almost doesn't look like a table at all—more like some very intriguing ice. I also like how the blossom seems to float over the surface. If I had been setting up a location studio, I could not have asked for a better situation. A pop-up tent provided a lovely softbox, cutting down on harsh sunlight and letting in early morning sidelight that helps differentiate flower petals for the viewer. In Hipstamatic, I shot the image with the John S lens and Blanko film settings.

## Robert Mapplethorpe

One of my favorite photographers of flowers is Robert Mapplethorpe. I can remember a day when I was showing my mother some of his flower photographs in a museum—where they also had a display of his more controversial work. I was at least able to have her appreciate his technique and talent in photographing the flowers, and she was willing to see how he utilized that same technique with other subject matter. I am humbled by how well he saw and captured the essence of these amazing displays of nature.

# 13. Sticky Buns

## Foodie Culture and Traditions

I like food. I like to photograph food and I share pictures of food with friends and strangers. I will admit to pulling back from always showing food on my Instagram feed because I can see how some of my friends and followers might be turned off by the "foodie culture." But I do love to cook, and of late bake my own bread and brew my own cider and beer for family and friends. So, I have no problem photographing my creations or talking about how delicious they might be. I have really pulled back from photographing meals in restaurants—probably mostly to keep the peace at home. (Love you, Deb.)

In my family, there are certain traditions that must be observed. One is that there must be sticky buns or cinnamon rolls for breakfast or brunch on Christmas Day. The new area of dispute is whether they must be the "original"

◄ Additional images of mouth-watering treats.

> "The eye should learn to listen before it looks." – Robert Frank

**66** The longer I cook, eat, and photograph, the more I appreciate the hands-on look of something made with a personal touch. **99**

Pillsbury cinnamon rolls or if we can, in fact, improve on the traditions of the past and make homemade sticky buns.

## Lighting and Shooting

For the record, these are Left Coast sticky buns (*facing page*), made by my brother in his house and photographed in beautiful morning light by me. I love the golden color that my brother gets from the syrups and sugars he uses.

In this shot, I like the soft focus around the edges—and, of course, the hard sidelighting really provides something special. Part of what helps in this image is the repeating shapes of the buns, as well as the differences in each shape because they are handmade. The longer I cook, eat, and photograph, the more I appreciate the hands-on look of something made with

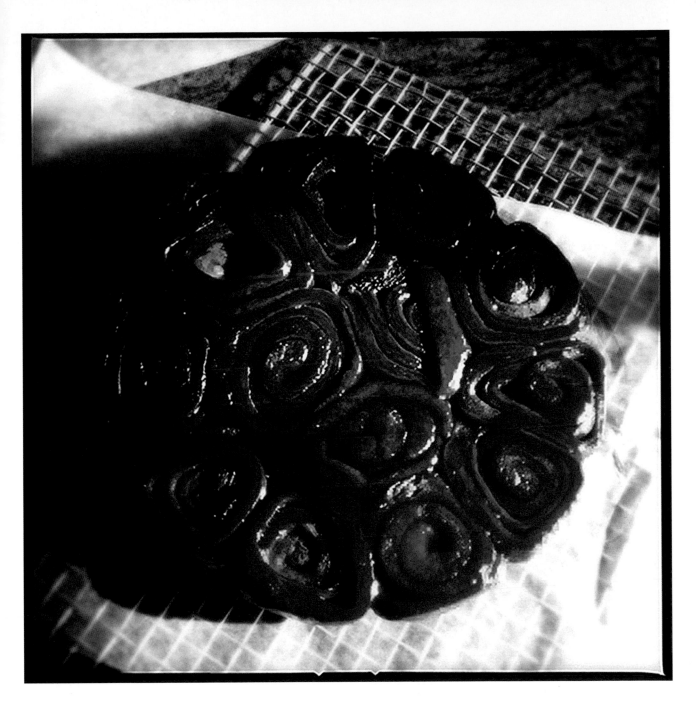

a personal touch. (I must admit, though, that I *do not* miss the hands-on developing of photographs or film. I am thankful for digital.) I shot the image in Hipstamatic with the Tinto 1884 lens and Catelli's DC film settings.

In my opinion, a food photo is successful if it makes your mouth water. When you see it, you should want to eat the food. If you can almost taste the food in your mouth as you are looking at the shot—bonus. (And, yes, these sticky buns were delicious. My brother is a great cook.)

# 14. Glassware

While I have pulled back from photographing food at the table, it is harder to resist glassware. The ability of glass to transmit and modulate light, and to hold black or produce white lines (see sidebar), makes it a fun thing to work with. I can remember my Photo 2 professor Dennis Defibaugh shining his lights through a glass block while teaching us to use lighting in the studio. (I also loved how he pronounced "cookie," the short version of cookaloris, with his Texas accent.)

## Martini Glass

In the main image *(facing page, top)* I really like the overall composition as well as the

contributing background that gives you a sense of place—a bar. I also like the contrast between the warm red of the drink and the yellow lights in the background against the cool cyan from the sky reflected in the granite of the tabletop.

In Hipstamatic, I shot this with the John S lens and the Blanko film settings. The Kelvin filter in Instagram really helped saturate the warmer colors as well as bump up the contrast of the overall image.

I can tell you that it was a delicious cocktail—and that there was a candied cherry at the bottom of the martini glass.

## Opportunity Knocks

One of the more fun moments I've had taking pictures at the table occurred when I saw a dog's face lit up on a glass that was delivered to our table at Pace Food + Drink in Santa Barbara *(facing page, bottom)*. I made the image, toned it, and moved it to Instagram. I then showed it to our friend Chris who demanded to know where and how I had made the image—since he was sitting at the table, too. In his defense, the light on his side of the table was not half as interesting as it was on mine. I think

### White Lines on Black

Here you can see what I mean when I talk about seeing white lines on a dark background when photographing glassware. A glass will transmit the dark background color (black in this case) while the light can also create a white line at the top rim. This contrast helps you give depth and shape to photographs of glassware.

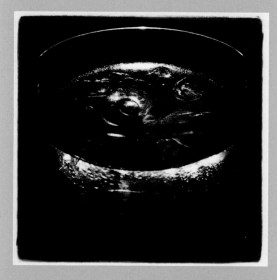

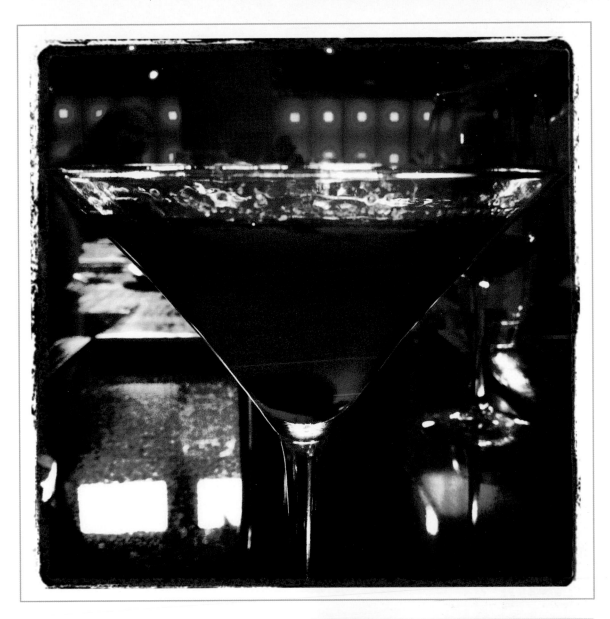

it was because there was some skylight that came down behind me to light up my glass of water. Add the dog's face on the glass and the highlights and you get a fun image while dining with friends and family.

I should also note that Amherst Media has an entire book dedicated to photographing these types of subjects. Glenn Rand's *Lighting and Photography Transparent and Translucent Surfaces* will help you really dig in deep on the subject.

# 15. Chocolate Factory

One of the fun things that can be done with phone photography and apps is arranging photos in grids and starting to make visual sentences with your work.

## Image Collections

I had the opportunity to do this on my latest trip to Belize with the Self Development of People, where I photographed John the Bakerman in Placencia *(below)* and the ladies at the Cotton Tree Chocolate Factory in Punta Gorda. The chocolate "grid" *(facing page)* tells a fun little story of the cacao bean becoming transformed into chocolate—something I enjoy eating on a regular basis. I shot the images in Hipstamatic with the Loftus lens and W40 film settings. I used the Diptic app (Square Format) to combine the images into a collection.

## Challenges

One of the hurdles of working in the Cotton Tree Chocolate Factory was that it is literally one room with not a lot of space to turn around or get into positions to make pictures.

## Visual Memory

In creating this collection of photographs, I leaned heavily on my memory. I can remember almost every picture I have taken with my camera phone and where they are in relation to each other. I will not claim that I have a photographic memory—or even a good memory (my wife can attest to that), but I have developed a very strong memory for images.

The importance of doing this was brought home by my Photo 1 professor, Millard Schisler. He had us complete an assignment where we selected a street and shot a roll of film, making whatever images we wanted to. Then we had to act like we lost the roll of film and shoot a second roll, trying to make the exact same images. Suffice it to say, I failed miserably at this—but I learned. I have actually thought back on this lesson multiple times when I have had to re-shoot assignments or mentally review a shoot to make sure I had everything covered. Your mind can learn these things and how to keep track of images if you train it.

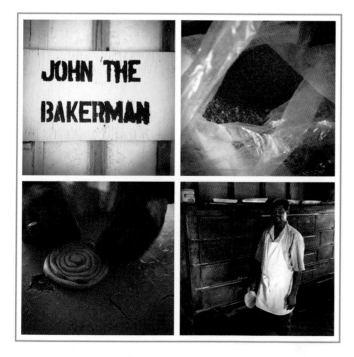

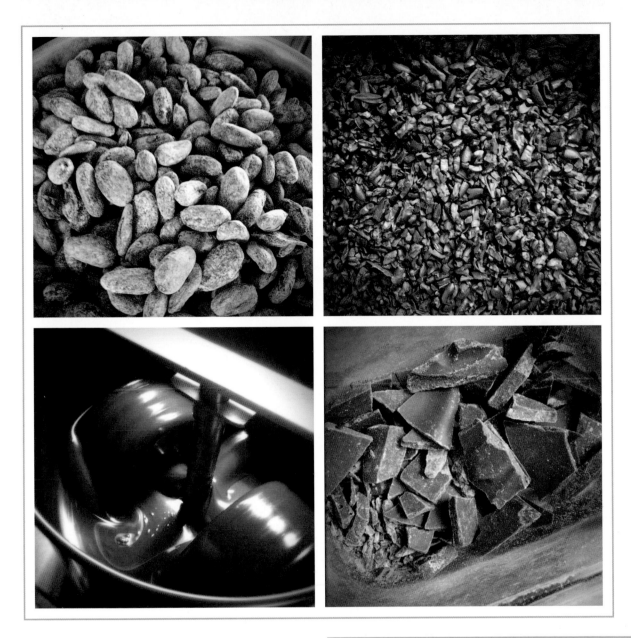

What does all of this have to do with a chocolate factory? If you are keeping track of what images you have made and from what perspective, you can then think in terms of a story or what images you need to fill in the holes. You can also avoid duplicating your efforts. Even when shooting casually as I enjoy time with friends (and taste chocolate), these skills can still help me make photographs.

"To me, photography is an art of observation. It's about finding something interesting in an ordinary place . . . I've found it has little to do with the things you see and everything to do with the way you see them." – Elliott Erwitt

# 16. Bacon Bread

In my family, the men bake the bread. This started with my father, who used to knead dough at night in our family's kitchen, and it has been passed along to his sons. My brother jumped into the deep end of the culinary pool by baking French style breads in his home—and I have followed along, as all good brothers do.

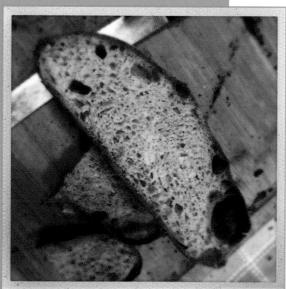

One of my favorite moments in our recent past was my brother trying to get more steam in his oven by pumping up a giant super soaker and spraying into his oven. This, hopefully, gives you a sense of our obsession with bread. (This is also probably the time to fully disclose that the wild yeast starter in my house was given to me by my brother. His daughter named their starter Toby, and a friend of mine christened our Toby Too as Tobias—and the name has stuck.)

When things are going well, my brother and I post pictures of our latest loaves—or we share ideas visually (like using silicone pads in the enameled cast-iron Dutch ovens). It is one way to keep in touch as well as to feed our families. And my friends are usually happy to get a phone call that there is extra bread to share!

## More Than Just Tasty

A cookbook called *Flour, Water, Salt, Yeast* (Ten Speed Press, 2012) really pushed our bread making to new and delicious levels. One of the recipes is for bread with pieces of cooked bacon in the dough, as well as bacon grease mixed in.

I was slicing a loaf of this bread for dinner one night when I noticed the early evening sun streaming through our back window and falling onto the cutting board where I was slicing away. Needless to say, I realized that I could backlight the slice of bread and not only see the bacon

◄ Additional images of some other bread-baking projects.

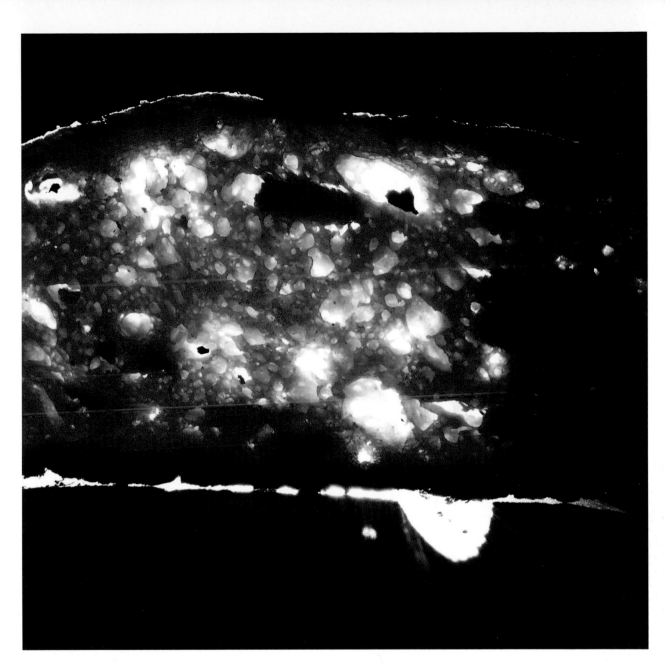

but also the crumb, as the wild-yeast inspired bread is translucent in some very fun ways *(above)*. My bamboo cutting board beneath the slice added some fun, simple texture to the image as well as reflecting a bit of the light shining through the bread.

The trick, as with all food photography, is to photograph the bread so that it looks the way that it tastes. In this case, I used Hipstamatic with the Lowy Lens and Ina's 1982 film settings. I finished it with the Lo-Fi setting in Instagram.

> "Do what you can with what you have, where you are." – Fortune cookie

# 17. Chinatown Snowfall

I love street photography—I'm always looking at other photographers' work and I keep shooting away, trying to develop my own style.

## Inspiration

For me, the preeminent street photographer was Gary Winogrand—although Elliot Erwitt gives him a run for his money some days. After Winogrand's death in 1984, they discovered nearly 2,500 hundred rolls of unprocessed film and over 6,000 rolls of film processed but not proofed. The man made picture after picture, and I think I admire him for his work ethic as much as his eye.

## Out the Window

I suppose this is a lazy person's street photography, shooting from my hotel window while it snows. I really like the perspective from the added height and how it condenses the snowfall so that a light dusting looks like more of a storm and starts to affect how we see the buildings and pedestrians across the street. This is one case where fewer pedestrians makes for a

> "To take photographs means to recognize—simultaneously and within a fraction of a second—both the fact itself and the rigorous organization of visually perceived forms that give it meaning. It is putting one's head, one's eye, and one's heart on the same axis." – Henri Cartier-Bresson

more dynamic image. I love the three out-of-focus snowflakes or drops on my window that surround the head of the person in the black coat. I also think that the coats of the people in the main frame *(facing page)* are more varied and interesting than some of the other images in the outtakes *(below)*.

I shot this in Hipstamatic with the Jane lens and Ina's 1982 film settings. The contrast from the Instagram Lo-Fi filter helped give the photograph some punch. I really like how the awnings start to sing and contrast with

▼ Variations on the same scene.

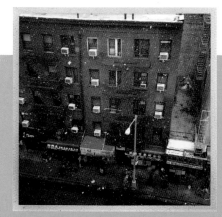
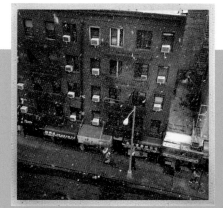
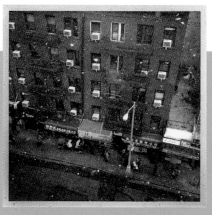

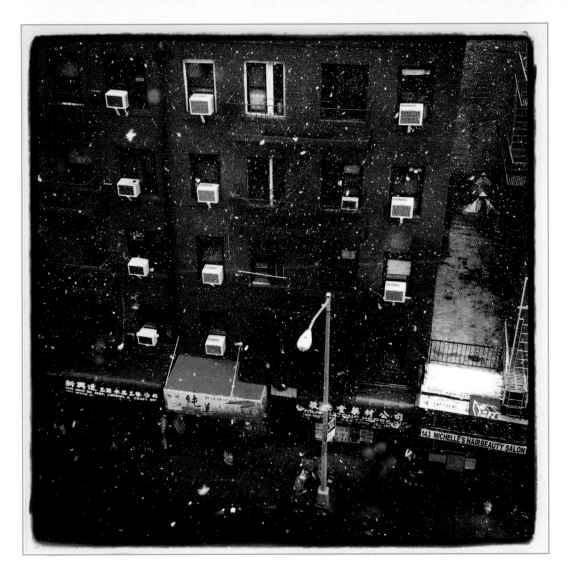

the pedestrians' jackets. I am a sucker for grid patterns and repeating lines and shapes. I love how the buildings across the street help frame the action on the sidewalk, drawing our gaze down to the people once we see the snow.

## Slices of Life

One of my first collections of work in college was called *Slices of Life*, and that is what I think this photograph is. It is just an interesting moment that I hope helps the viewer think about their day, their walk home, their street, the weather, or living in a city. Hopefully, the viewer brings something to the photo that I do not control, allowing them to connect with the image and have it fit, however briefly, into their day. That is the amazing and frustrating part of photography. People will look or not look. Experience or not experience. Connect or not connect. As photographers, we try to keep grounded. Sometimes that holds us back, but other times it helps us soar when we make interesting pictures that ask interesting questions. Isidor Isaac Rabi tells how his mother would ask him, "Did you ask a good question today?" So, have *you?*

# 18. Getty Staircase

In *As You Like It*, William Shakespeare wrote, "All the world's a stage, and all the men and women merely players; they have their exits and their entrances, and one man in his time plays many parts." Truer words have not been written or spoken—which is probably why this is one of Shakespeare's most famous quotes.

> "To consult the rules of composition before making a picture is a little like consulting the law of gravitation before going for a walk." – Edward Weston

## Getting Naked

Like many photographers, I feel a bit naked showing you the series of images that set up the best photograph. However, I once had the chance to see Michael Williamson, staff photographer with *The Washington Post*, show an entire slide tray of images that he called "almosts" – and I learned so much from him in that session! A book about *National Geographic* photographer Sam Abell (*Sam Abell: The Photographic Life*, Rizzoli, 2002) shows some of his photos in the same way. It is easy for students to look only at pictures that *work* and assume those were the first and only frames the photographer shot. (But, man, I still feel vulnerable letting folks see what goes on in my thought process and visual editing!)

## The "Stage" and "Actors"

Sometimes, I like to look for a good or interesting "stage" (an interesting place, location, composition) and then wait for my "actors" to appear. To some photographers, this might be a backward idea, but I have seen it work many times. In a way, it's a very Taoist thought or approach. David LaBelle also discusses this technique in his book *The Great Picture Hunt 2: The Art and Ethics of Feature Picture Hunting* (Kernel Press, 1995). What I have found (in life and photography) is that if I am patient enough, people will do far more interesting things than if I were to direct them or tell them what position to get into.

## Lock in the Composition, Wait for the Action

The advantage of this approach is that I can get my composition locked in—or at least understand what I want to keep in the frame or exclude—and then wait for the right moment or human interaction. In this case, I started out by playing with how the fabric panels in the windows modulated the architecture, but then realized that the staircase became a very

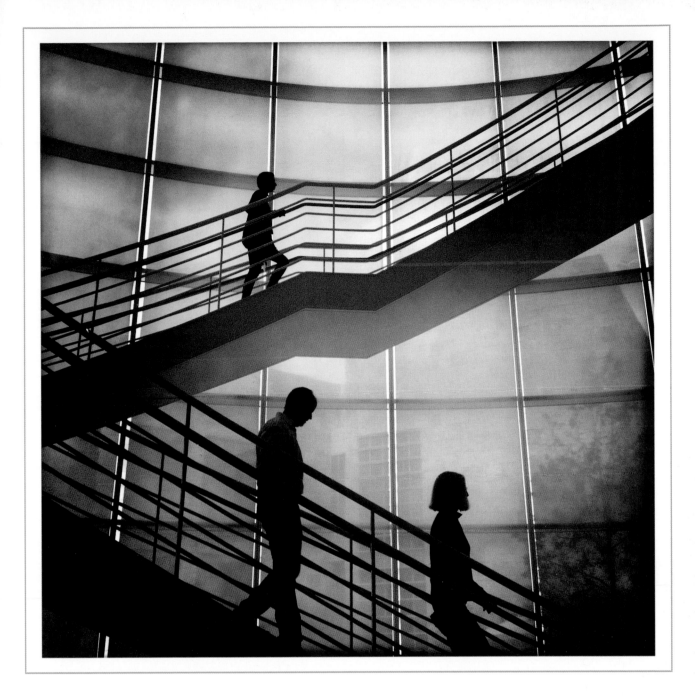

dominant and interesting part of the scene. That made me move from the top of the staircase to halfway down. There, I waited for the right combination of people in the right positions on the staircase. Using Hipstamatic, I shot the scene with the John S lens and Blanko film settings.

66 If I am patient enough, people will do far more interesting things than if I were to direct them or tell them what position to get into. 99

# 19. Oz

## A Photo Safari

A few years ago, my father and I went on a photo safari in Los Angeles. Late at night, we found ourselves outside the Walt Disney Concert Hall downtown. After we located a parking place (it took a few minutes of circling to find something legal), we hopped out and started making pictures. I believe my wife and my mother tired of our behavior fairly quickly that evening and found a comfortable place to sit down while we explored the scene.

## The iPhone in Low Light

If there was ever a situation where I might worry about the abilities of an iPhone in low light, this would have to be it.

As I started photographing the wonderful stainless-steel exterior designed by Frank Gehry, I loved the way the light fell on the building—and I realized that I had a chance to make an image that felt and looked different than the many daytime images I have seen of the hall. The lights, combined with the film

> "John Loengard, the picture editor at *Life*, always used to tell me, "If you want something to look interesting, don't light all of it." —Joe McNally

(Blanko) and lens (John S) combo I had set in Hipstamatic, had a strong green cast, so my imagination immediately turned to *The Wizard of Oz* (perhaps even *The Wiz*). That's just where my imagination went.

In the image I like the best *(facing page)*, things really started coming together and working well. The shape and form of the building, the highlights, the falloff of the light on the higher parts of the structure, the green cast, and the night light of Los Angeles really work in harmony.

In motion picture terminology, the horizon is "Dutched" because the composition feels better to my eye when I take the building off true horizontal. In more traditional architectural shots of this site, you don't get the same energy or looming quality; you can easily tell you are

▼ Variations on the same scene as I honed in on the final look.

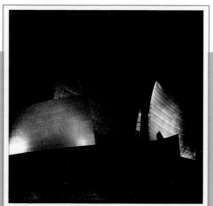
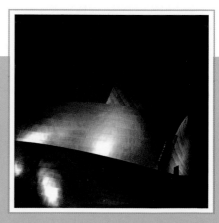

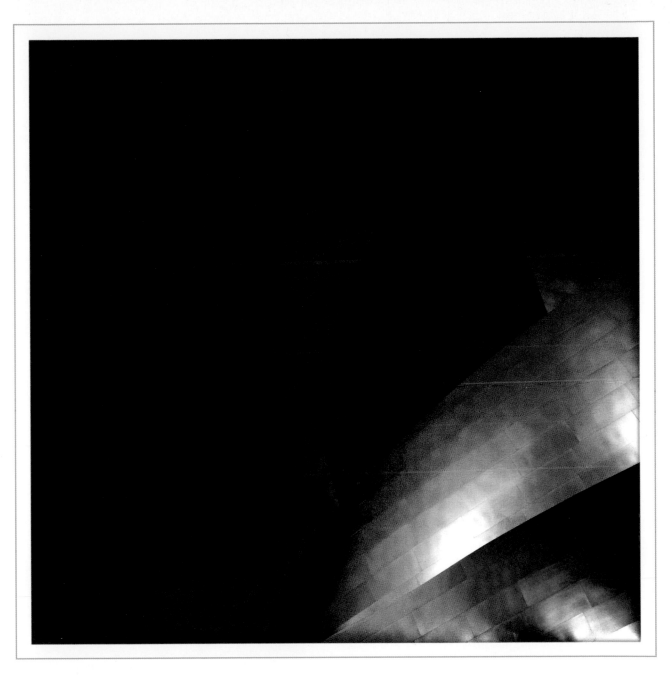

looking at Disney Hall. With this image, I think it is less obvious and therefore more open to the viewer's mind going in different directions. The abstract quality of the architecture and intentional angle also provides some strong horizontal movement to the image.

After we finished taking pictures at the hall and wrapped up walking around downtown it was off to The Pie Hole and a slice of something made in an Italian style that was both rich and delicious—not unlike our time making pictures in the dark together that night. (I also think this was the beginning of me and my brothers thinking about getting Dad a new camera.)

# 20. The Padre

## A Landmark

One of the landmarks in Bakersfield, CA, is the Padre Hotel. Its giant sign makes it hard to miss. A remodel has made the building into a destination, as has its very colorful history. Milton "Spartacus" Miller purchased the hotel in 1954 and operated it for the next 45 years. Mr. Miller got into numerous arguments with city government and his responses included hanging giant signs from the side of the building—and ultimately building a canon or missile (depending on your version of the story) on the roof of the hotel, aimed at City Hall. It was never fired in either version of the story. When Mr. Miller died in 1999, he lay in state on the bar top of the hotel lounge. A local man who considers himself to be Clark Kent and wears a cape and superhero outfit beneath his regular street clothes delivered a eulogy for the colorful owner of the hotel.

## Beyond the Expected

In local photo competitions, we see the familiar building in multiple entries. It was right across the street from my office for seven years, so it was hard for me not to photograph it, too.

But how do you make an interesting image of such a popular landmark? You have to be patient and wait for some interesting weather; in Bakersfield, that translates to two to three opportunities in seven years. The image that I like the best *(right)* utilizes a Tule fog for atmosphere and to blur some of the physical

> "I like to feel that all my best photographs had strong personal visions and that a photograph that doesn't have a personal vision or doesn't communicate emotion fails."
>
> – Galen Rowell

properties of the hotel. I love the red glow around the sign in the fog that sits heavily near the ground in winter here in the San Joaquin Valley. I also like the tree (providing some sense of scale), the red stop light at the bottom center of the image, and the natural vignetting of the hotel as the light drops off in the dark of night.

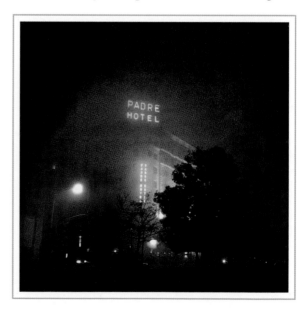

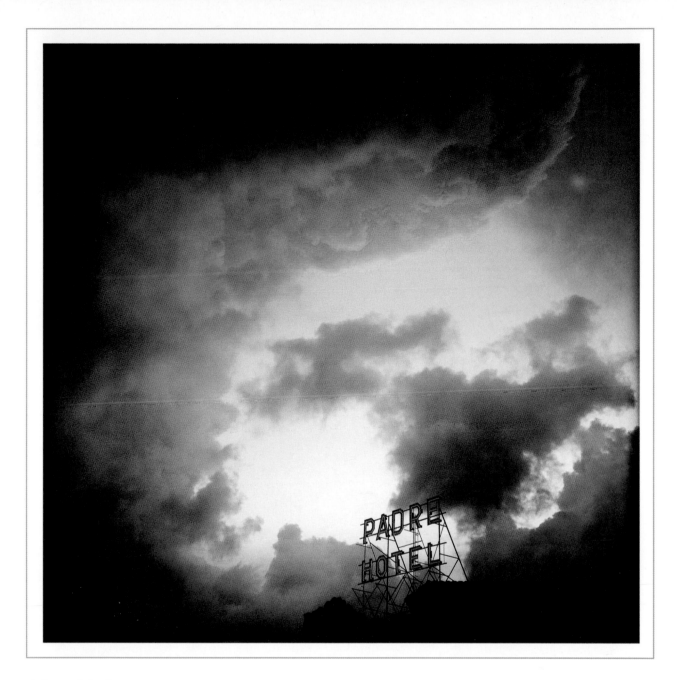

## A Second Series

Another great photo opportunity *(above)* happened when some amazing rain clouds sped through the valley right around sunset. I quickly climbed the city parking lot structure across the street from the newspaper and The Padre to get some elevation so that I could focus in on the rain clouds and the sign. Sometimes, luck favors the prepared—but other times, luck favors those who are willing to hustle and get into the right position!

I have photographed the building on other occasions, but those two moments really stand out in my mind.

# 21. Escher-like

At some point in our lives, we all come across the work of M.C. Escher. I will not pretend to explain why his images work so well, but I will quite happily use the visual language that he pioneered to make an interesting or challenging image (*facing page*). Yes, with a little thought you can get your eyes to see which way the steps are going, but I like that with a slight suspension of belief I can begin to see them going the "wrong" way, too. My eye starts moving around the image, looking for places that support whatever view my mind sees. Too big a stretch, perhaps, for what amounts to an architectural photograph— but that is how my mind works and how my eye sees the world. (It could also be my sense of humor. Ask my wife.)

## Playing with Perspective

I have been working on making Escher-like photographs since my time in school where I experimented with perspective and "tricking" people's eyes. I built an entire collection of images flagrantly bending the "photographic

> "Still photographs are the most powerful weapon in the world. People believe them, but photographs do lie, even without manipulation. They are only half-truths." —Eddie Adams

guidelines" (and having way too much fun). My eye and my mind are deeply attracted to this idea, perhaps even obsessed. It is curious to me the things I played with as a student and now return to as a professional. And I should note that I am really thankful for the professors and mentors that I had in school; to this day, I am still utilizing what they taught me. Gunther Cartwright and W. Keith McManus really fostered my work in developing my personal style, and even though I never had Loret Steinberg for a class, she still looks at my work and helps me keep my moral compass. I know I will forget some folks; it is not intentional. There have just been so many mentors along the way, and I thank them all for their help.

▼ Some additional images made at the same location.

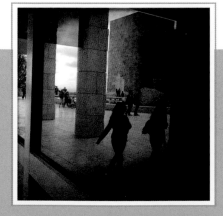

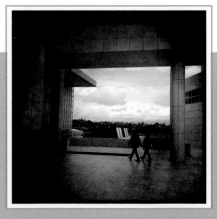

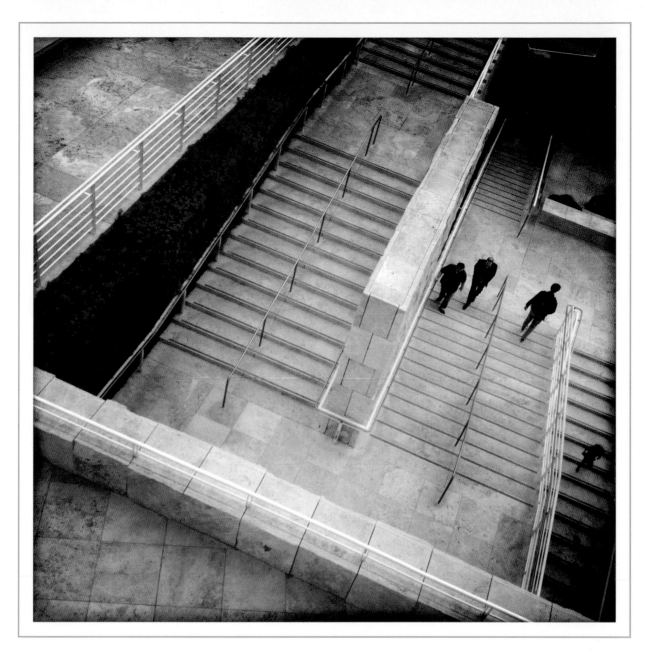

## At the Getty

On this visit to the Getty, I really worked on my perspective, getting up high and sometimes getting down low. The museum, high on a hill in Los Angeles, is a remarkable location that just begs the photographer to explore. Sometimes, I don't even get inside to see the exhibits—I am having too much fun outside with light, shape, human beings, graphics, and architecture. What I was certainly trying to do was trick your eye or at least get your brain to ask some serious questions of your eyes.

In this image, Hipstamatic's Blanko film setting added a texture and cast that worked well with the John S lens setting. They accentuated some of the effects I was working for and helped hold the picture together.

# 22. Airports

I have spent a lot of time in airports over the past few years. The more I travel, the more things look the same . . . and the more I look forward to sleeping in my own bed next to my wife. On the other hand, I have become something of an aficionado of airports—a connoisseur, if you will. I am not sure that is a good thing. I think what saddens me the most is how antiseptic they all look. So why do I keep making photographs in these places? Primarily because I am there and, secondly, I often have nothing better to do.

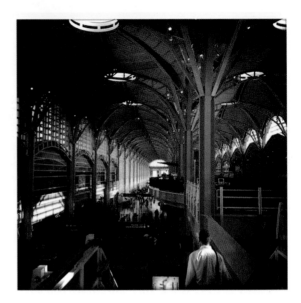

## A Favorite Image
My favorite image from my travels is from the Reagan National Airport in Washington, D.C. *(top right)*. It has a very *Wizard of Oz* feel for me—and, as I am sure you know by now, I am a sucker for the repetition of shapes. I also like the sense of depth produced through the foreground, the man, the midground, and the background.

I don't mind the vignetting at the top of the frame, and I like the fact that the main

part of the image is offset into the center left of the image itself. The man with the highlight of color on his shirt really helps keep the photograph together and establish the foreground. Without him, it is a boring photograph to say the least.

I also like how the muted color palette works in this image; it's atypical when compared to other images in the book, but the subdued tones work in this shot. Notice how things seem brighter and lit more healthily or normally off

▼ Some additional images made at airports.

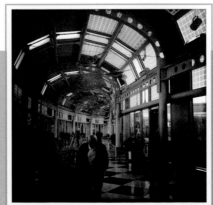
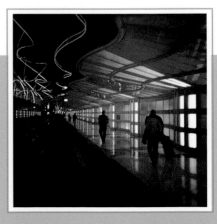

### Scenes That Resonate

I can hear the critics now: "It's just a photograph of an airport—a small one, at that!" I can't help that. I can only try to convey the thoughts that go through my head before or after I make a picture, find a picture, or discover a picture where I wasn't looking for one before. These scenes and subjects sing to me, or at the very least resonate with my soul. I cannot help but make the images. Sometimes they whisper to me from the very edge of my consciousness; other times, they yell. Either way, I lift my camera to my eye and I go to work. Click.

in the distance. It is a good metaphor for our human existence as we look to the future and hope things get better—or as we envision the "promised land."

In Hipstamatic, I used the John S lens and the Blanko film settings.

> "Sometimes one waits too long for the perfect moment before snapping the picture. You never realize that all you needed was to change perspective."
>
> – Miguel Syjuco

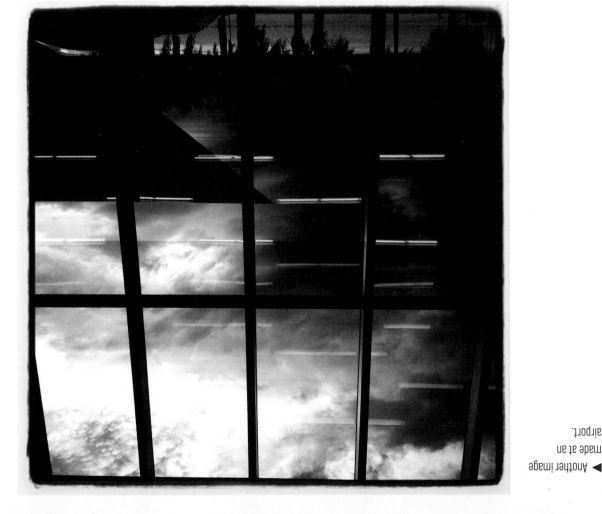

◄ Another image made at an airport.

# 23. Bridge

The David L. Lawrence Convention Center in Pittsburgh, PA, is an architecturally fun building to photograph. I was in Pittsburgh for the 220th General Assembly of the Presbyterian Church and found myself with some free time in between meetings I was supposed to be at, catching up with friends. One of the things I liked to do was wander around the building, trying to utilize the unique architecture.

## A Good Find

The image that I like the best from this take (*facing page*) utilizes some 2-D design techniques and makes me feel like I am somewhere on *Star Trek's* Starship Enterprise. I think it is how the windows tilt out toward the river at such an angle. Also, the grid of the glass is mirrored by the ceiling tiles at the top of the frame. In Hipstamatic, I shot the image with the John S lens and Blanko film settings. In Instagram, I adjusted it with the Kelvin filter.

> "Good photographs are taken not with the camera. Good photographs are taken with Mind, Soul, Eyes, and imagination—where Eyes like a shutter, Mind like a lens, imagination like an object, and Soul like a canvas." — Parveen Sharma

## Try, Try Again

There was also a really cool water sculpture beneath the convention center. I spent a good part of one afternoon working from as many angles as I could find to try to make an interesting photograph—I couldn't. Another area that had some potential is seen below. Here, I started playing with the graphic, man-made shapes and the sky—but I couldn't quite get that to work either. (On the upside, a high-school friend's sister noticed that I was in Pittsburgh and told her brother. Almost 20 years after our graduation, we caught up and grabbed a Primanti Bros. Sandwich—so I feel as though I got a good visit to the City of Bridges!)

I wish I had been able to make the skylights and floor light work better, but the exposure range was just too much for the camera.

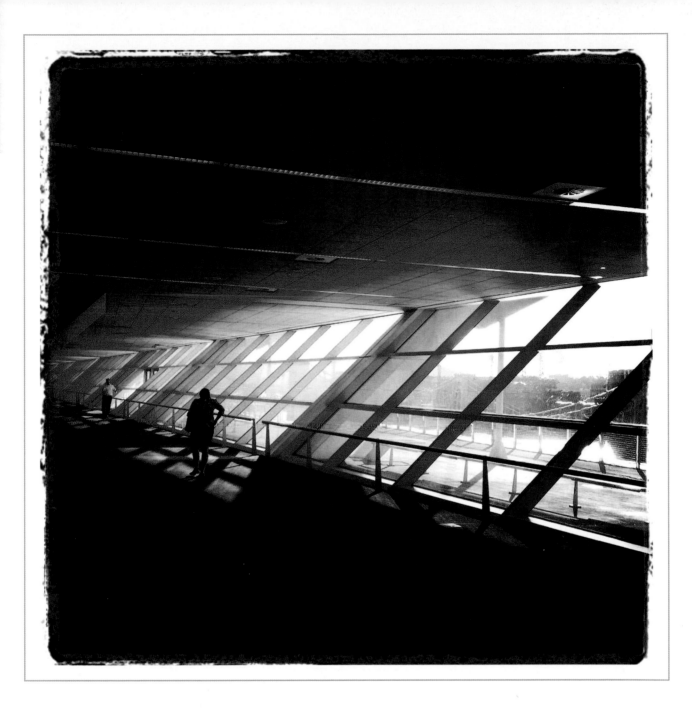

▼ Some additional images made at the same location.

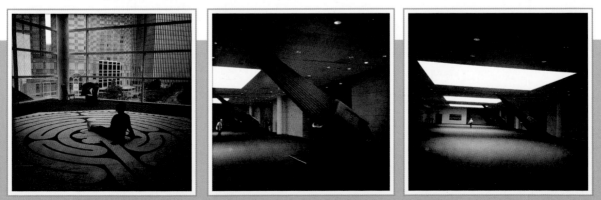

# 24. Low Earth Orbit

I have spent a fair amount of time in the air over the past several years. I usually try to get a window seat so that, if I am awake, I have the chance to make some images.

## A Simple Change . . .

I freely admit to tiring of the "usual" iPhone images that people seem to post to their Instagram feed from airplanes.

A simple change in the orientation of the horizon *(facing page, top and bottom)* put things in a whole new perspective, making it appear that we have an image from low Earth orbit. I suppose it's a bit misleading; even a few years ago, changing the horizon is something that would have never occurred to me—or my personal ethics would have prevented me from taking that action. Today, though, I think it just makes the image more interesting to look at.

Over time, and as I have gotten my ego farther out of my work, I've learned that making an interesting picture is really the key.

> "The whole point of taking pictures is so that you don't have to explain things with words." – Elliott Erwitt

Even though the main image is not "true" in the sense that we were not flying that steeply or that high, I would argue that it is true in the sense that it makes me appreciate the world. It also raises some very interesting questions, like how did I get a camera into that position?

I love the glow at the edge of the horizon that starts looking like the atmosphere of our Earth. I am sure that astronauts or JPL engineers would vehemently disagree and provide five reasons why this is not true—but that's also fine with me. That's what it looks like *to me.*

In Hipstamatic, I used the John S lens and Blanko film settings for this shot.

▼ Here are some other interesting images shot from airplanes. Playing with lens and film combinations, including parts of the plane in the frame or excluding them – these are all important questions to ask and options to explore. The height of the trip and the amount of cloud cover are two really big variables none of us phone photographers can control, but that doesn't really bother me.

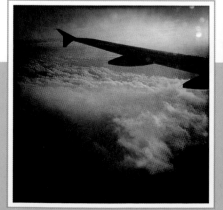 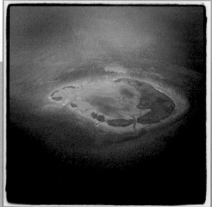 

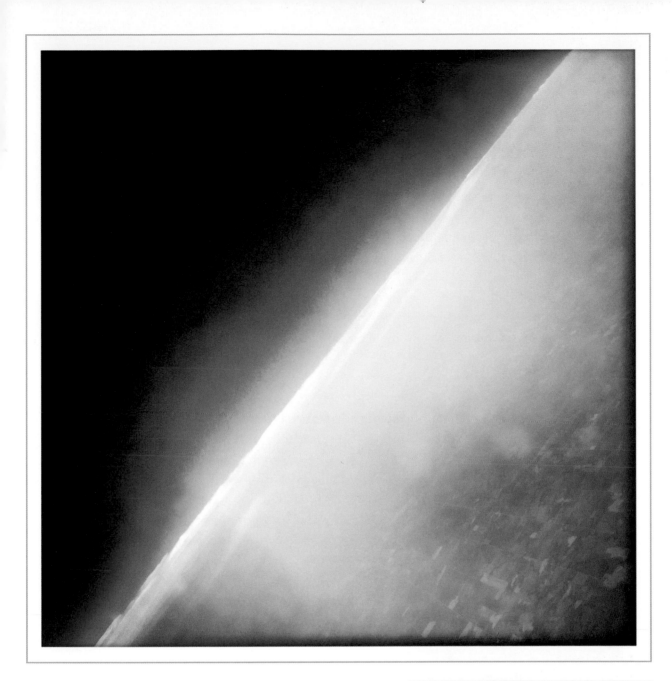

▲ ▶ The original image (right) and the final image with a tilted horizon (above).

# 25. Where the Wild Things Are

As we walked down to the beach on a cold morning in Cambria, CA, I saw this driftwood structure and immediately wondered if Max from Maurice Sendak's *Where the Wild Things Are* was here—it looked like where he would live. (Yes, my mind went to the book—but having seen the film by Spike Jonze after making this image, the film could be referenced as well.)

## Composition and Style

I like the strong diagonal from the driftwood leading you into the photo from the bottom left of the frame. The "shack" balances out the driftwood cone and prevents your eye from traveling up the diagonal and out of the frame. One of the more interesting parts of this photograph is the dark rectangle of the door. We can barely see past the opening, so we are not sure what is in there. The ocean and sky complete the atmosphere of the image. Hipstamatic's John S lens and Blanko film settings enhanced the scene with a film-like feel.

"You don't make a photograph just with a camera. You bring to the act of photography all the pictures you have seen, the books you have read, the music you have heard, the people you have loved." – Ansel Adams

## What the Viewer Brings to the Image

I imagined what Max might have felt staring at that ocean. But does the viewer *need* to think of the book to appreciate the image? I don't think so. I'd be happy if that is where their mind went without my prompting—but I can also imagine other experiences people might bring to this scene. Maybe a sense of anticipation for a beach party tonight, or a sense of sorrow that they missed a party last night, or a tingling sense of wondering who is in that shack. Good images raise more questions than they answer.

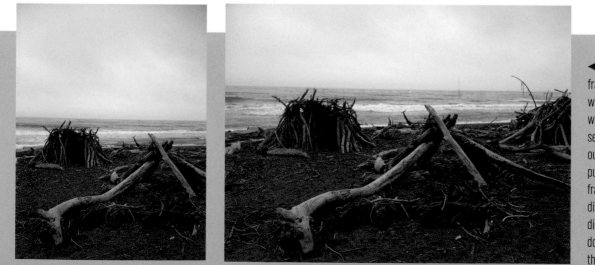

◄ What I framed up worked fairly well; you can see from these outtakes that pushing the framing in different directions didn't do anything for the image.

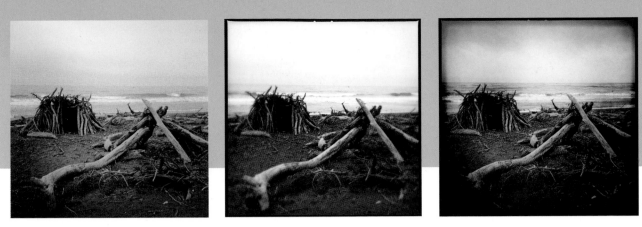

▲ Some alternate finishing options I tried before settling on the final look below.

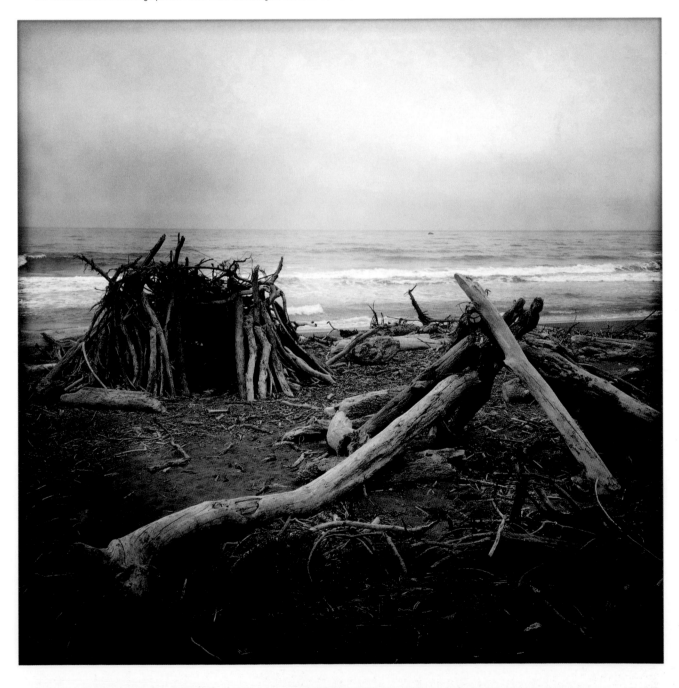

### Body Language

There is just something very engaging and energetic about young children, especially when they are at the beach. Here *(below)*, our younger subject pulls the hand of the older as she charges off into the surf—probably to turn around and run when the next wave starts rolling in. What makes this image work for me is the body language of the pulling as well as the human touch of holding hands. We have

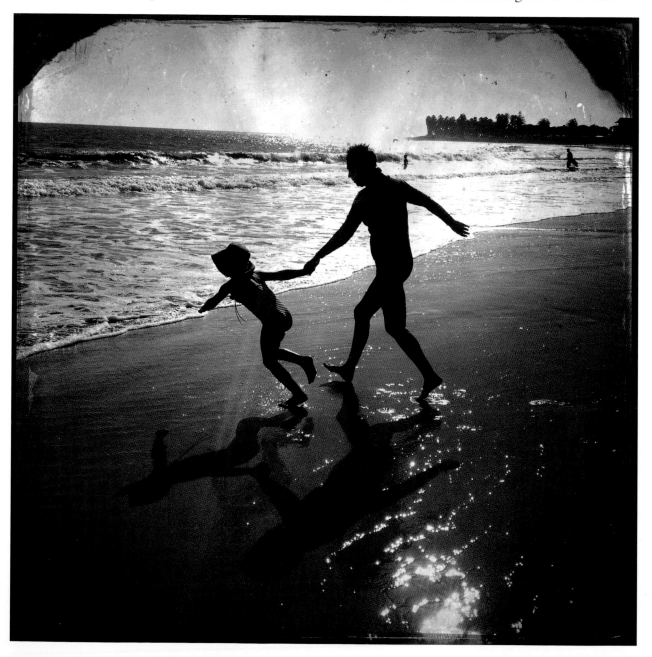

all wanted that reassurance of a parent or friend as we charge into the surf.

## Processing

I honestly can't tell you why I went with Hipstamatic's Lowy lens and C-Type plate that day. I can tell you that it works visually, but there wasn't something that screamed out from the subject matter and told me to use *this* look. More often than not, I think we get seduced by what we can do with our camera or phone's camera or what the app might let us do, rather than focusing on the content or making an interesting picture. In this case, I believe that the image works; I can't shake that feeling that my gut reaction was right and that I made the correct choice.

## A Quiet Moment

My second favorite image from this day is a quiet black & white shot of two subjects standing in the light surf, looking out at the Pacific Ocean. If we are quiet and the wind is blowing the right way, it feels like we might be able to hear a little bit of their conversation. There is a connection there, a relationship—if only we could figure out what. I remember my Photo 1 professor Millard Schissler bringing in a set of dolls in and asking us to write a short paragraph about them. Almost all of us wrote about the typical nuclear family with a mother, father, and two children. No one stopped to imagine other possibilities. We were trapped by "traditional" roles and typical toy sets.

## A Second Look

Take another look at the image on the facing page. Is it important what the relationship

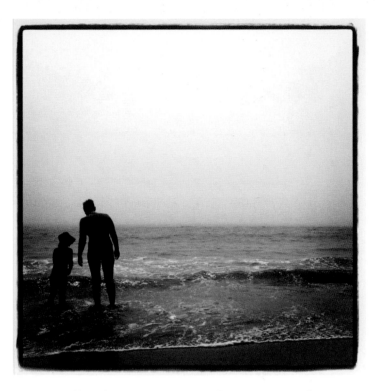

actually is between our two subjects? Not really. Of all the images in the book, I hope this is one of the photographs that elicits an emotion. I see this moment and think of the pure joy of being a child at the beach with my brothers and parents—and I imagine what it might be like to be at the beach with a daughter. There are some things that are universal, whatever culture we might come from. Holding a hand of another as we charge off into the unknown has to be one of them.

> "The dharma is about letting go of the story line and opening to what is: to the people in our life, to the situations we're in, to our thoughts, to our emotions." – Pema Chodron

# 27. Sprinklers

Yes, I really did pull off the road onto a side street with our young foster daughter in the back seat so that we could walk back and I could make some pictures. I hope, over time, she gets used to her father doing odd things for photography, or making portraits of her, or asking her to go somewhere, or wait a few minutes, or not roll her eyes while I do something with my camera.

## Opportunity Knocks

I can't remember where we were headed. It was an unusual time of day for us to be on that stretch of road—one I travel very infrequently. But when something catches your eye and screams to be photographed, I think it's important to take the time to shoot it. Park legally, be safe, and get back to what you saw. Then go crazy making images and chasing the light to wherever it might lead you.

## Lighting and Processing

The late-afternoon sun shining through the trees and water sprinklers really caught my eye. What I particularly like are the shadows cast by the trees that broke up the streams of water as they sprayed. Then, it became a question of sun

> "In my view you cannot claim to have seen something until you have photographed it." – Émile Zola

in the frame? Not in the frame? Modulated by a tree, object, or branch? I like the dancing of the light in the water and the sense of movement you get from the sprinkler water as it was sidelit by the setting sun.

In Hipstamatic, I shot this image with the Lowy Lens and Ina's 1982 film settings. From there, the edit became fairly obvious. One of the things a colleague keeps reminding me to do is tone or add contrast to digital photos, hence my use of Instagram's Lo-Fi setting on a regular basis. It works especially well with an image that has such a range between light and dark. The contrast works really well for this image, and highlighting the negative space of the tree shadows was really important to me.

## Listen to Your Inner Child

I have made two late-afternoon sprinkler images in two years in Bakersfield, and I appreciate

◀ Outtakes from the same scene.

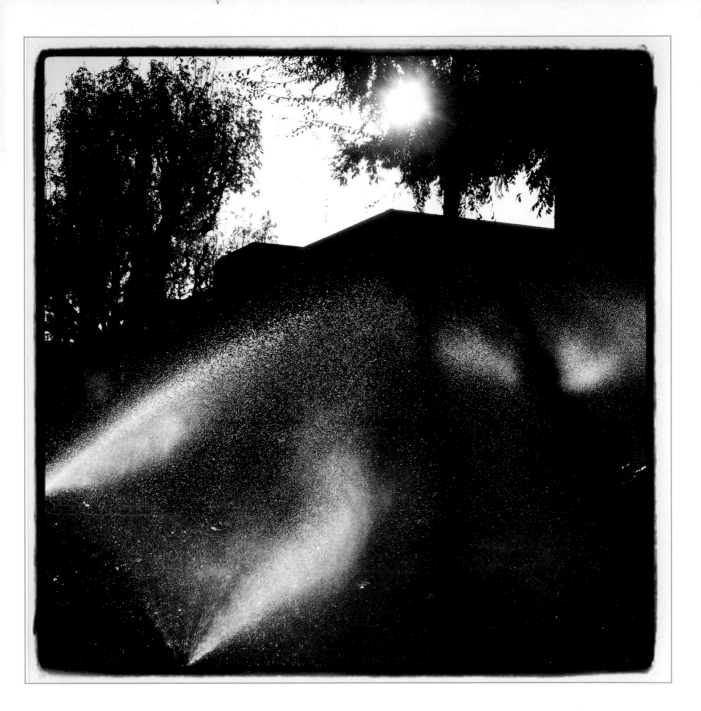

both of them for different reasons. I think what I like most about this image is that the little kid inside of me just wants to run into the water and get wet. All too often, we stifle that voice as adults—and I think our lives are poorer for it. There are times to rake leaves together and then jump in them, to stomp in puddles, or to run for sheer joy. We need to embrace those moments. I know that the camera is an excuse for me to explore our world and get to know it better. Now, perhaps I need to set my phone aside and get wet.

# 28. Pool Party

It could be argued that this photograph *(facing page)* falls under the category of self-portrait because of my shadow in the lower-left corner of the image.

## A Sense of Fun

There was much swimming on this family vacation to a Sonoma Valley rental house. As with many things that are the center of attention, the pool area became something I photographed regularly. Of all the images from that trip, I think this one best conveys the sense of fun and of the color and coolness of the water. There is energy in the frame from all of the pool toys and people splashing. It makes me want to jump right in (after I put my camera down, of course).

## A Classic Look

There is a long line of images with the photographer's shadow in the frame—it's a classic way to frame an image with the sun at your back. If I were shooting this for a

> "When you approach something to photograph it, first be still with yourself until the object of your attention affirms your presence. Then don't leave until you have captured its essence." – Minor White

newspaper, I would want to make sure that my shadow was not visible, but in this case I liked the fact that my shadow informed the viewer that I was present at the pool with my family. I do think it is helpful that my shadow falls on the cement so that it can be read easily.

I like the sense of a quiet summer's afternoon. I also like how the walls of the pool function as a frame within the frame, separating the blue water from the green grass and trees. I shot the image with Hipstamatic's John S lens and Blanko film settings.

▼ The other images I shot at the pool convey a sense of fun *(left)*, or motion *(center)*, or atmosphere *(right)*–but the shot on the facing page combines all of those things into one frame.

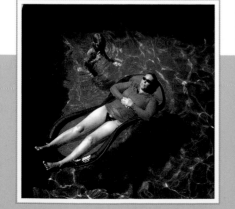  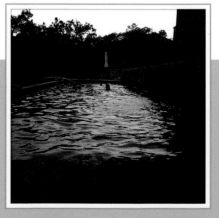

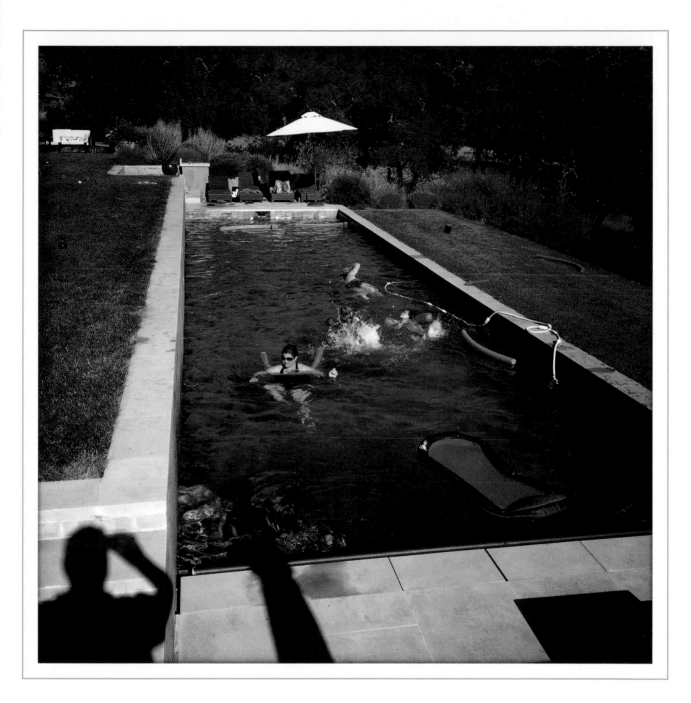

66 There is energy in the frame from all of the pool toys and people splashing.
It makes me want to jump right in (after I put my camera down, of course). 99

# 29. Totem Pole

## Location

I was fortunate to attend a Social Justice Retreat to meet with like-minded Episcopalians on the west coast. We convened at the Dumas Bay Centre just south of Seattle and spent two very intensive days talking about, studying, and networking on different aspects of social justice. The Centre is known for its lovely grounds and a great view of Dumas Bay on the Puget Sound.

## Challenges

During one of our breaks—and a break in the rain—I went for a stroll on the grounds and found this wonderful totem pole holding onto his tongue. The first problem I ran into was that it was an overcast day in the Pacific Northwest (go figure). Secondly, the camera wanted to lighten up the sculpture more than it should have because of the dark background of trees. My phone was also flattening much of the color in the totem and the contributing background of the trees. I shot the image in Hipstamatic with the Loftus lens and W40 film settings.

> "No matter how slow the film, Spirit always stands still long enough for the photographer It has chosen." – Minor White

## Postproduction

This is one of the few images that I had to go into with Photoshop because I could not get the level of control I wanted by selecting and toning the image in Filterstorm—which is saying a great deal about the app. (*Note:* As of the release of Adobe's Creative Cloud 2014, there is an app for the iPhone and iPad that allows users to access their favorite Adobe apps and all their files in the cloud. At the time of writing this book, however, I had not yet had a chance to work with this app.)

Overall, what I was looking for was highlighting and focusing the viewer's eye on the totem pole and the moss growing on it while providing a background that hints at the Pacific Northwest and makes the sculpture

▼ Some alternate treatments of the same image.

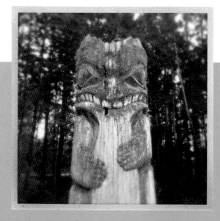
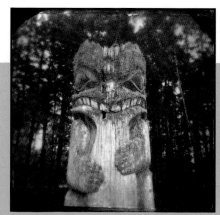
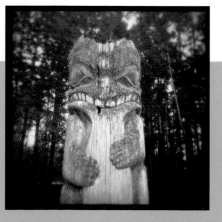

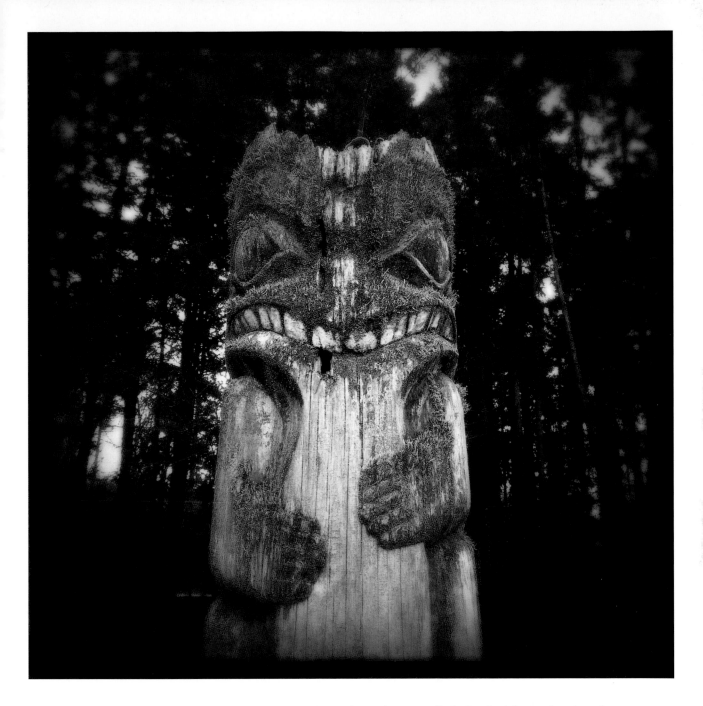

seem to appear to be just out in the woods. The tricky bit was, once again, toning the image to reflect what really was there on that day as well as what I wanted to see as a photographer.

While I wanted the background to give you some information, I did not want it to overwhelm or compete with the totem. The lens choice really helped with moderating the background, as did the distance between the totem pole and the trees; with the simple fixed lens that comes standard with the iPhone, it was just enough.

# 30. Sleeping Baby

I have had the opportunity to photograph this little guy twice, essentially a year apart, during visits to the southern end of Belize *(facing page)*. He and his mother have a special place in my heart. When we first met them in Punta Gorda, he was an enormous baby with a slight mother. We were thinking he might grow up to play football.

### Where Is He?

This time, I was talking with his mother and asked where he was. She just pointed at the wall of the kitchen where she and her coworkers were cooking *(see image below)*. I couldn't quite figure out what she meant, but she pointed again at the wall. After a minute, I realized that he was napping in a sling, quietly sleeping through all the commotion of our visit. A year later, he was much longer and thinner and his mother talked about him getting sick and losing some weight.

### Setting

His mother works at the Marigold Women's Group, a cooperative in Belize's Toldeo district.

> "Photography is a reality so subtle that it becomes more real than reality."
>
> – Alfred Stieglitz

66 When we first met them in Punta Gorda, he was an enormous baby with a slight mother. 99

Through this organization, a group of Mayan women have opened up a restaurant and are now feeding their community, travelers, and tourists along one of the country's major highways (a two-lane highway to you and me). With money from the Self-Development of People Committee, they built their own place,

▼ Some outtakes from the same day, including the kitchen area *(left)*. His sister *(center)* is also a cutie – and for a while this was my favorite image of the bunch. In the final shot *(right)*, you can see Mom and her two children.

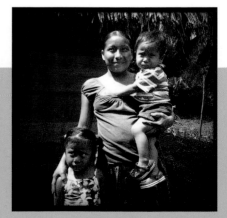

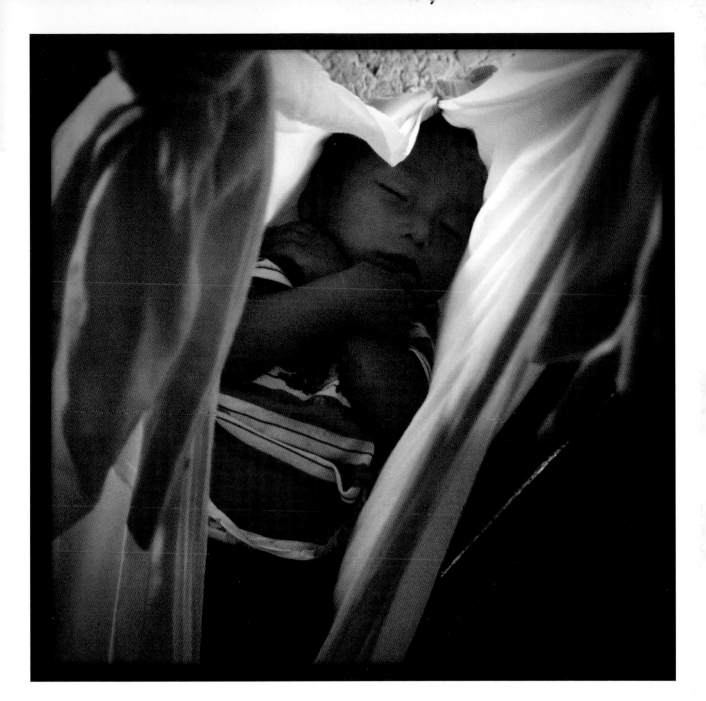

a concrete block building and a traditional thatched roof kitchen, and started helping themselves and their community.

## A Peaceful Moment

I think what I like about this image is that he is peacefully sleeping, arms crossed—and you get just enough information to read that he is sleeping in a sling. Deep down inside, I think all of us would like to get a nap like that, feeling safe and without a care in the world. I shot the image in Hipstamatic with the Loftus lens and W40 film settings.

# 31. Ansel Adams Tribute

As a beginning photographer, I was a big Ansel Adams fan (who isn't?). I wanted to be a nature photographer when I headed out to the Rochester Institute of Technology. Little did I know that once I started working for the student-run *Reporter Magazine*, my life and career would take a different path.

## Re-Creating the Ansel Adams Style

At school, we learned about Ansel Adams and the zone system. In fact, one of the few photographs that hangs on the walls of our house was taken with a 4x5 camera and previsualized by yours truly—exposed for the shadows, processed for the highlights, and then printed in the darkroom. If that sentence sounds like it was written in a foreign language, I apologize. It's how we learned photography with film. Why does this matter, you ask?

Well, with a lens setting, film setting, app, and a careful eye, I was able to make an image at Bridalveil Falls in Yosemite Valley that I could have made with a 4x5 view camera—but it would have taken me a long time to set up, focus, expose the film properly, safely transport the negative, develop the negative, proof the

> "Actually, it's nature itself that creates the most beautiful pictures, I'm only choosing the perspective." – Katja Michael

negative, and then make a print. Instead, I pulled out my iPhone and made an exposure with Hipstamatic's Loftus lens and Rock BW-11 film settings. Then I got to work and loaded it up to Instagram during lunch at the Lodge.

In the outtakes, you can see how a lower-contrast look doesn't work for the image. As with DSLRs and other cameras and equipment, the phone camera wants to balance the exposure of my image to 18 percent gray—so getting a correct exposure requires being smarter than the camera. After a little work in the Filterstorm app, pulling down the midtone segment of the S curve, I had an image that I would proudly display in my home. Perhaps I might even tip my cap to Ansel as I walk by or as friends admire the photograph.

▼ Lower-contrast versions of the image don't have the same pop.

## Film vs. Digital

I am sure Ansel is cursing at me from heaven at this moment. Why does that tickle me so? Because I learned photography traditionally, at a good school, and I can now go out to Yosemite and get a very similar look, very easily—disturbingly easily—and without getting frostbite. You won't hear me bemoaning the changing face of photography. This field has always been advanced by discovery and new techniques, and I have always been glad that other people enjoy doing what I sometimes get a paycheck for doing.

# 32. Sunrise Texting

## Always Be Ready

As Joe McNally has advised, "Don't pack up your camera until you've left the location." In this case, I had packed up my gear and was walking back toward our guest house outside Punta Gorda, Belize, when I saw this young man pedaling along *(below)*. The fastest thing I could get to was my phone.

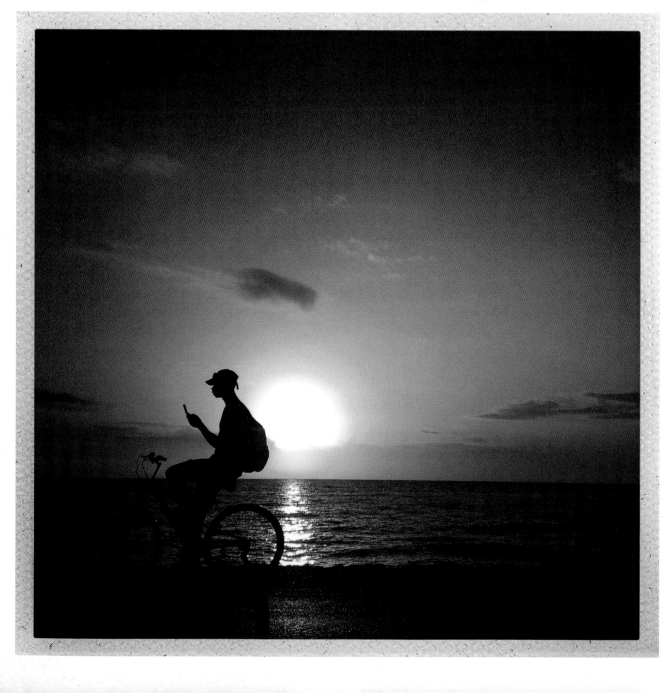

## Shooting

This was definitely a time to get low and try to frame as much of the rider as I could against the water and sky. It's a happy coincidence that you can look at the scene and imagine that he is sitting on the horizon. I had hoped to get him in front of the sun, but I don't mind him riding out of the frame—in fact, I think it helps. With Hipstamatic, I used the Jane lens and Ina's 1982 film settings to capture this image.

## A Larger Message

In one sense, I think this image is just eye candy—a beautiful sunrise, a strong silhouette, and a humorous moment—but I do think it gets at a larger issue if we take a second look. While I am impressed that this young man is able to ride hands-free and text from his bicycle, it is a little disheartening to think that he is not enjoying the light and the moment.

Cell phone use is now so ubiquitous, even in one of the poorest regions of Belize, that we've all seen people out in public, or out with friends, who are focused more on their phones than the world around them. This is not a screed against cell phones—I quite like mine and, after all, this is a book about using one as a camera. That being said, we should be cautious about what we might lose. (Right now, my wife is giggling uncontrollably as she reads this.)

▶ Some other images from the same morning.

"To photograph is to hold one's breath, when all faculties converge to capture fleeting reality. It's at that precise moment that mastering an image becomes a great physical and intellectual joy." – Henri Cartier-Bresson

# 33. Flight

People have dreamed about flying like birds since before Icarus, and we have been trying ever since. It is one thing to head down to the beach with my DSLR and a long lens to make some interesting images of birds; it is another to grab my trusty phone and do the same thing. It's a waiting game; you line up the shot you want and then stare at the screen, hoping the little Vs fly into the frame.

### The iPhone Forces You to Think

As I was walking along the beach, I noticed something very important. From time to time, the seagulls would fly along the cliff face. They didn't do this in a predictable fashion, but after making some test images *(below)*, I realized where I needed to be positioned. Yes, it was that simple: notice the birds' flying habits, visualize where I might move to take advantage of that, and wait. I feel sort of guilty that the

"God creates the beauty. Through my camera, I am a witness." – Mark Denman

solution was that simple—but that's what I love about using my phone as a camera; it forces me to think, be creative, and maybe take a hike so that I can make an interesting image. I can't stress that enough. I can't solve visual problems with lenses or a quick shutter speed. The work I do *in my mind* is much more important. Shooting with my phone forces me out of my comfort zone and helps me rediscover why I love photography.

### Shooting

Once you are in position, you still have to make an interesting photograph. In the image on the facing page, I really like the wings on the lead

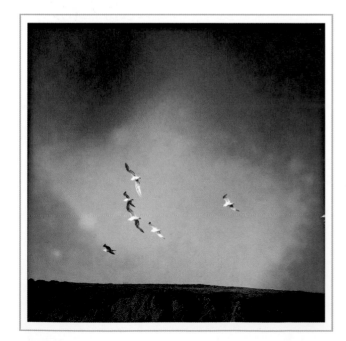

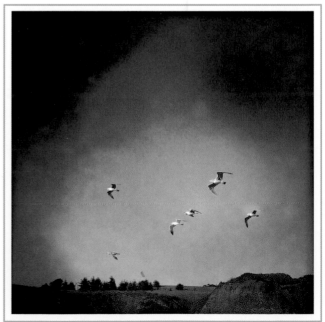

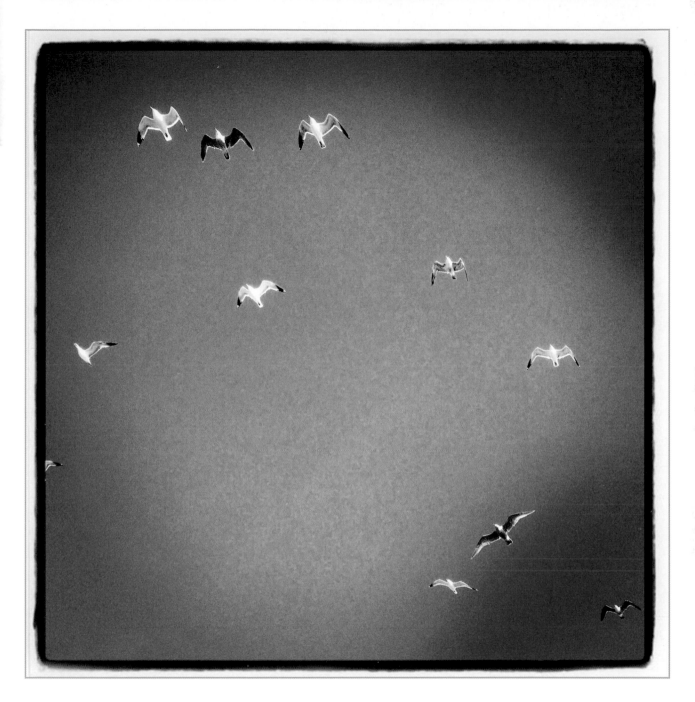

bird; it seems to be carrying the sun on its back. I like how the John S lens and Blanko film work together to give that Holga camera vignetting and a film feel. I can almost hear the ocean waves crashing and the cries of the birds to each other. I wish that I could strap on wings and join them over the water.

66 Shooting with my phone forces me out of my comfort zone and helps me rediscover why I love photography. 99

# 34. The Streets of Bakersfield

In Bakersfield, CA, we have some very interesting limitations on street photography. It gets hot in the summer—really hot—so folks are not out on the street a great deal. We also have really boring weather; it is almost always sunny, without many clouds in the sky. (I know, you feel so bad for us.) For a newspaper photographer, though, this is a problem because the seasonal images are taken right off the list. There are very few leaf-raking pictures to be made, very few snow-shoveling or snow-blowing photographs, and even rainy days are very infrequent. So, the challenge for me over the years has been how to work around these limitations.

## About This Image

This image *(facing page)* makes me think of Henri Cartier-Bresson's photograph of a giant wall in Madrid—minus the man and children in the foreground. That gives you a sense of how my mind works. I like the large wall here, dominating the single figure walking along the sidewalk. The cars in the foreground are mostly

> "For me, the camera is a sketch book, an instrument of intuition and spontaneity." – Henri Cartier-Bresson

outlines, and I can almost feel the heat of the afternoon sun beating down on the man and the building. I like the repeating shapes of the "windows" on the building; they form a useful grid for the photograph. In Hipstamatic, I used the John S lens and Blanko film settings.

## An Unofficial Anthem

The unofficial anthem of Bakersfield is "Streets of Bakersfield," written by Homer Joy, popularized by Buck Owens, and then launched again by Dwight Yoakam. That, in and of itself, may be a very strong metaphor for Bakersfield and our existence in the valley: we seem to reinvent ourselves on a regular basis, yet the DNA remains very similar. The chorus of the song goes:

▼ Some other examples of street photography – although not all from Bakersfield.

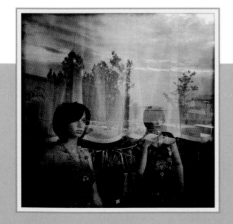

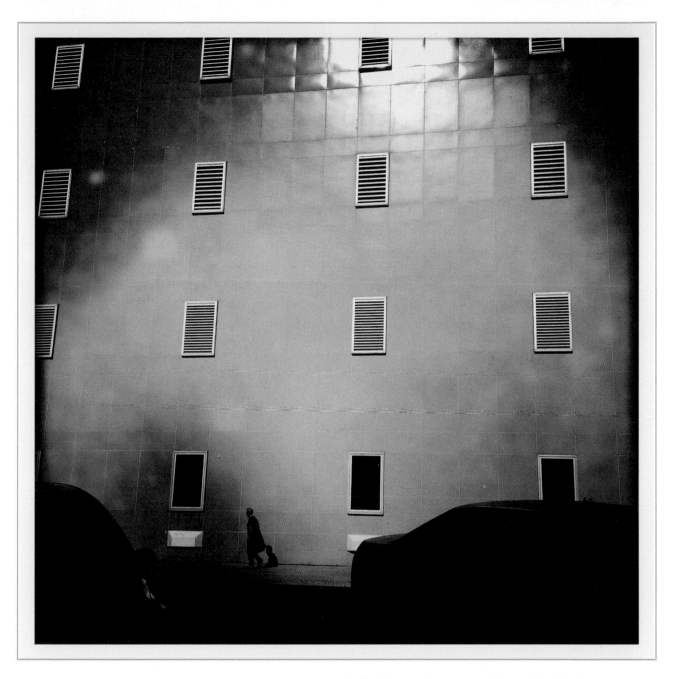

*You don't know me, but you don't like me*
*You say you care less how I feel*
*But how many of you that sit and judge me*
*Ever walked the streets of Bakersfield?*

Not unlike Homer Joy, I keep walking the streets of Bakersfield, keeping mostly to the shady sides and, to quote him again, "trying to find me something better." I have occasionally worn blisters on my heels, and I am much closer to understanding why, when this song comes on in a bar or is played at a concert, we all start singing along.

# 35. Departure

For eight years, I volunteered with the Presbyterian Church (USA)'s Self-Development of People Committee. It is a ministry of the national church that seeks to empower disadvantaged people around our country and the world. Part of that work involved visiting the groups we might be funding. As I traveled for the work, I also visited a fair number of airports around the country and took a lot of pictures.

I enjoyed my time serving on the committee and had the chance to work with some amazing fellow committee members as well as a fantastic professional staff. I was also given the opportunity to go and meet with groups from Seattle and San Diego to San Francisco and Baltimore. I even ate some gumbo in South Plaquemines Parish, LA, cooked by members of a fisherman's cooperative—food you could only hope to smell and enjoy in Louisiana. It was very rewarding work, and I had the opportunity to make pictures around our country and even overseas.

> "The editors of *Life* rejected Kerész's photographs when he arrived in the United States in 1937 because, they said, his images 'spoke too much'; they made us reflect, suggested a meaning—a different meaning from the literal one. Ultimately, photography is subversive not when it frightens, repels, or even stigmatizes, but when it is pensive, when it thinks." – Roland Barthes

## Between Terminals

I took this photograph (*facing page*) while traveling on a small bus between terminals at the San Francisco Airport. There were not too many of us on the shuttle, so I had my phone out (probably checking my e-mail) when we emerged from a small tunnel and I saw this

▼ Some other images documenting the experience of air travel.

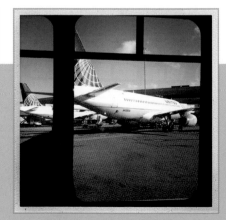

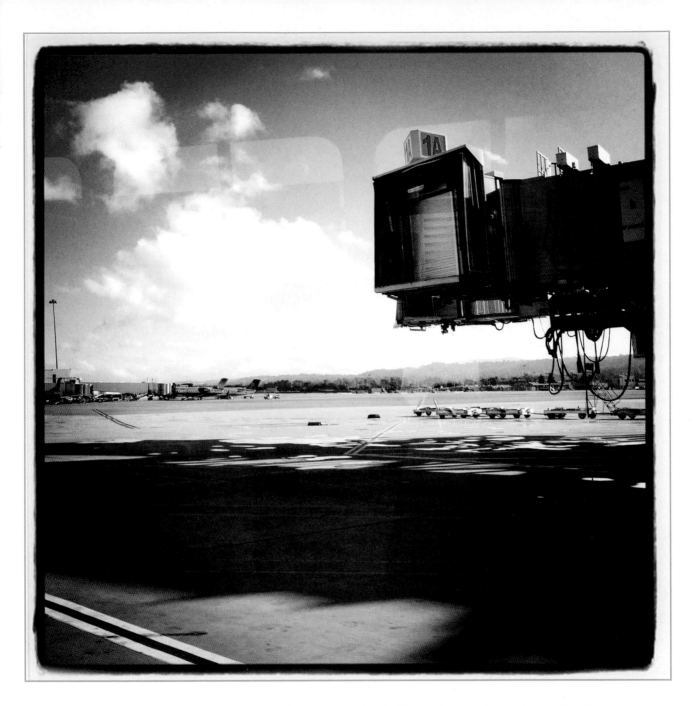

moment. I captured it in Hipstamatic with the Lowy lens setting and the Ina's 1982 film setting. In Instagram, I used the Lo-Fi setting.

In this case, what makes the photo is what is *missing*. I can imagine who just left or who might be arriving. There could be a feeling of anticipation or one of sadness. Or, as Freud opined, "Sometimes a cigar is just a cigar"— so, for some people this might be just another airport gate. It all depends on what you and your imagination bring to the reading.

# 36. Communion

In all of photography, editing is the key. There are many times when editing or post-processing can get you out of a jam and help you focus on what was working while you were engaged in the process. That being said, when you can do the editing in-camera, the images become stronger and things are easier when you get back to your computer.

## Composition and Shooting

In this situation (*facing page*), I found the perspective I was looking for fairly quickly and easily. The last little touch that works for me is the addition of the wave breaking on the right to just "tie the room together," as the Dude (from *The Big Lebowski*) would observe.

For me, this is also a successful image because that is my wife looking out and communing with the Pacific Ocean. In one sense, she is a lighthouse standing watch; in another, she is insignificantly small in relationship to the world. Another way to "read" the image is that she has blended right

> "All photographs are *memento mori*. To take a photograph is to participate in another person's (or thing's) mortality, vulnerability, mutability. Precisely by slicing out this moment and freezing it, all photographs testify to time's relentless melt." – Susan Sontag

into the world. I know how much she loves water, oceans, and the Great Lakes in particular, so it is meaningful to me to have a photograph of her in one of her happy places where she is simply enjoying life.

Another reason why this image works for me is that it keeps to the guidelines of photography and really moves the horizon off of the center. It breaks the Rule of Thirds guideline by including so much sky—but it does so purposefully.

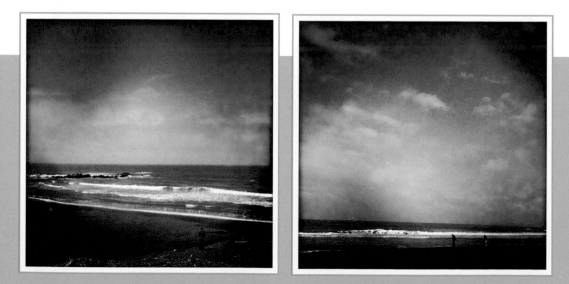

◀ Some other images documenting a day on the shore.

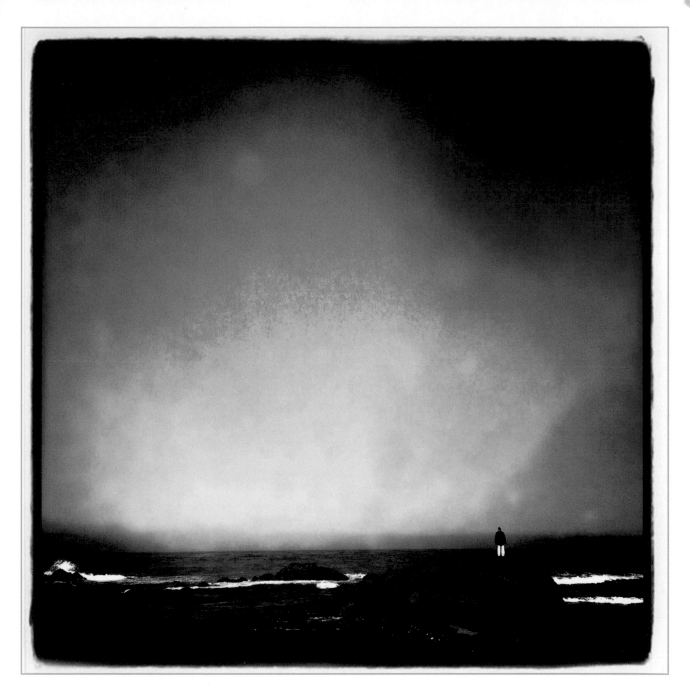

## Finishing the Look

I shot this image with the John S lens—and I do like the faux film feeling that the Blanko setting in Hipstamatic gives this image (although as I have shot more with my iPhone, I have moved away from the obvious film analogues). The increased contrast from the Lo-Fi filter in Instagram gives the photo a little extra kick or spice.

# 37. The Liquid Artist

Every two years, my family gathers for a reunion convened by my mother and then later hijacked by me and my brothers. It keeps all of us in touch and generally provides a good excuse for us to cook, drink, and enjoy each other's company. Every now and then, the three sons will also organize field trips that intersect with our areas of interest.

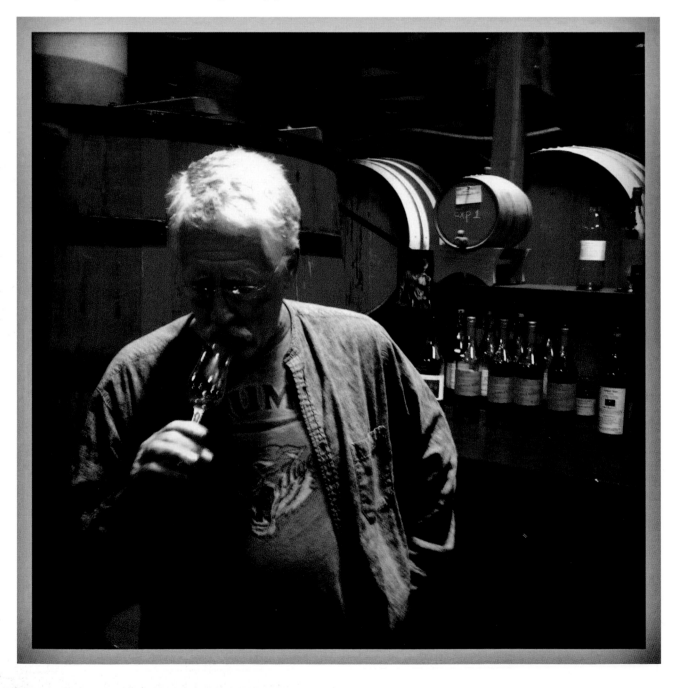

## At the Distillery

In this case, my youngest brother somehow wrangled us a visit to one of the preeminent brandy distillers in the United States—no mean feat. We had an amazing visit, although I do not want to know how he got us in or how we had the cofounder giving us the tour and leading the tasting. Even if you don't partake, a tour of a winery, distillery, or brewery is just interesting and very visual for the photographer.

## Lost in the Moment

After the tour, we settled down for the tasting. What caught my eye was how the co-owner got lost in the scent of the brandy as he led us through their liquid library. I have seen movies where a character gets caught up in the memories a scent recalls, but I had never witnessed this in real life. In this image *(facing page),* I wanted to give a sense of place—the barrels and bottles in the background—but it is really about the moment he gets lost in his craft. As a photographer, that is when I quietly pull out my camera or phone and get ready. I shot this image using Hipstamatic with the John S lens and Blanko film settings.

I like how he is framed by the large barrel behind him, the bottles of our tasting lined up behind him, and even the different shapes and sizes of the barrels in the frame. The concentration on his face, the pause before sipping, the chiaroscuro light on his person—it all brings me back to the experience. As it happened, the entire magical web was almost broken when my youngest brother asked a simple, honest question that caused our host to wonder if we were engaging in industrial espionage—but once that misunderstanding

▶ Additional images from the distillery tour and tasting.

was dismissed, we made our way to the store. A bottle or two of that brandy still sits in our house to be enjoyed with friends on special occasions. And, of course, we tell the story.

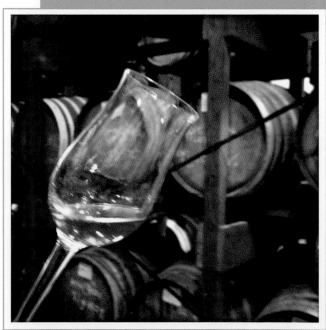

# 38. Rings

The day I made this image was one of those magical moments with beautiful light along the ocean in Santa Monica. The location is probably obvious to anyone who is familiar with Los Angeles—right near the pier at the traverse rings. There were some people with gymnastic braces on their hands who were much more proficient at the rings than others; this person even had knee pads.

### Composition and Shooting

What is curious for me is that, despite all the angular and swinging images I shot *(below)*, the one that works best for me has a more static quality to it; the subject is hanging nearly perpendicular to the ground *(facing page)*. I think what makes it successful is his body language, the juxtaposition of his feet to the passersby, and the silhouettes of the merry-go-round and Ferris wheel in the background.

Technically, this is my typical combo of Hipstamatic lens (Jane) and film (Ina's 1982), plus an Instagram treatment (Lo-Fi). However,

> "The camera makes you forget you're there. It's not like you are hiding but you forget, you are just looking so much." – Annie Leibovitz

breaking one of the photography "guidelines" is what makes this image work: shooting into the sun. For me, silhouettes work very well with the camera phone. By stripping away all the bells and whistles of my DSLR, I am forced to use that most critical of tools: my brain.

I think "just using a cell phone camera" also helped me in this situation because folks were not put off by a professional-looking photographer. (Yes, there were other people there shootings stills and motion that day in the same location.)

### Losing Yourself

This was just one of those times when I lost track of time—I was completely focused on making images, playing off the angles, shooting

▼ Some alternate images of the same subject.

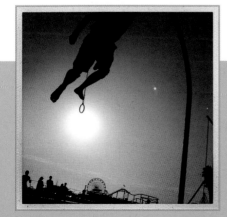
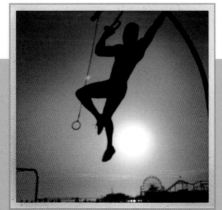
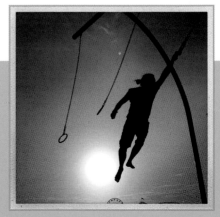

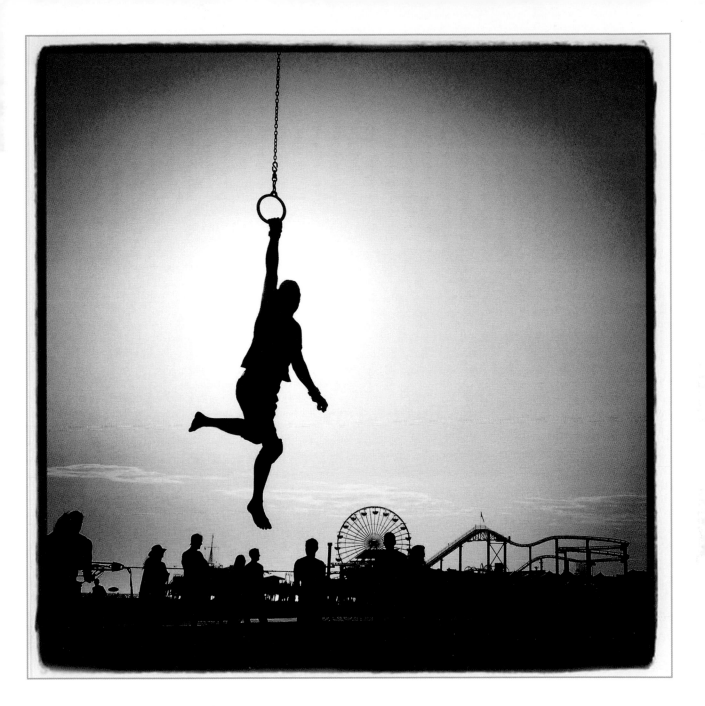

into the sun. Like many artists, I am constantly seeking to immerse myself in "the flow" of work so that my images come from a very authentic place. For me, the flow is critical. When I'm in it, I am not pre-judging things or editing before taking pictures. My ego is way in the background and I am just seeing the world for what is there at that moment. Add the mesmerizing sound of the ocean in the background, the throngs of people, the interesting crowd at Venice Beach and Santa Monica, and photographers are very happy. A friend of mine heads down to this location regularly.

# 39. Office Shadow

For the last few years, when I've been away from my office at the newspaper, my "other" office is Dagny's Coffee Company, run by a man named Mike Walters. What I most respect and like about Mike and his staff is that they have created and maintained an atmosphere where people can hold meetings, creative types can talk, folks can enjoy a philosophy session, and others can study the Bible without anyone feeling excluded or that they are not welcome. (One of the best examples of the sense of community that Dagny's is nurturing occurred when a friend's brother died in an tragic accident. There were nearly a hundred people from the coffee shop at his memorial service—if for no other reason than to support our friend and his family.)

## Lighting

The afternoon sun does some amazing things in that store—and sometimes it can bounce off of car windows and all the way into the back room of the shop. You've probably already guessed

> "A picture is a secret about a secret; the more it tells you, the less you know." – Diane Arbus

that I really like color, shadows, and silhouettes. I can't explain why; my eye is just caught by them. I think part of my attraction is that taking away the details that make us different from each other helps make the images more universal. I also think that it has something to do with the strong graphic quality these subjects bring to my photographs. If color is used in the background, or a spot color appears in the frame, I think it really accentuates what a shadow can do.

## About This Image

I really like the texture that the wall brings to this image *(facing page)*. The strong lines of the electrical conduits don't bother me as much as they did when I was making the image. I also like the golden tone the light picked up as it bounced off a car window and hit this black

▼ Some alternate compositions created using shadows.

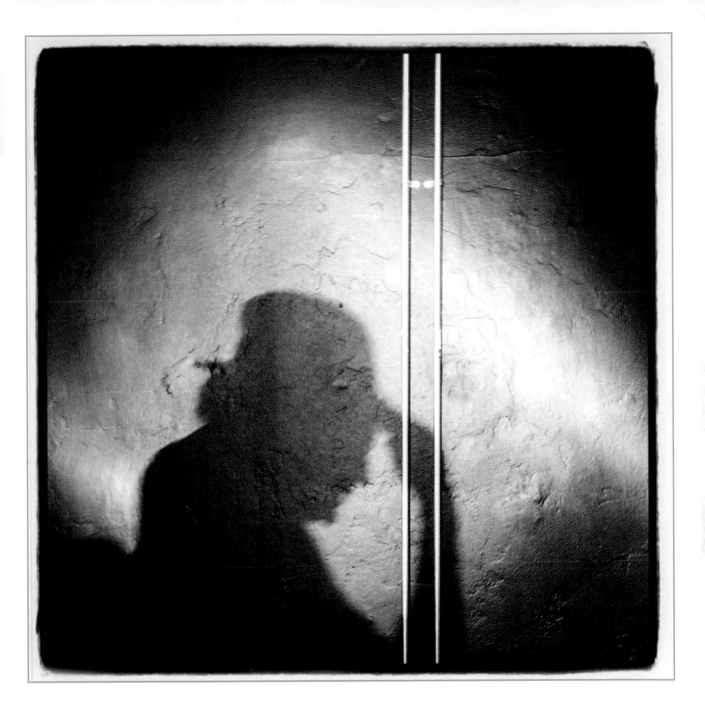

wall. Yes, in real life that wall is solid, matte black and you can hardly see any of this detail in it.

I shot the image in Hipstamatic with the Jane lens and Ina's 1982 film settings. The natural vignetting of the car window reflection was accentuated by Instagram's Lo-Fi filter to help keep the viewer's eye in the frame. The gesture of our subject also helps make the photograph work. Is he thinking? Wiping his brow? Is it even a *he*? Is that a cowboy hat?

# 40. Field Crew

## Arrive Early

I have had a lot of luck photographing at baseball stadiums over the years. I think it is because things have a fairly standard order; I can pick up the rhythm of the ball park as I see what is going on during the pre-game "dance" of events. Good photojournalists like to get to events early so that they have time to settle in, catch players in less scripted moments, and perhaps even get out onto the field. It doesn't always happen, but that's my ideal situation.

The Sam Lynn Ballpark is a classic American Class-A stadium. The fun twist for this stadium is that the batters have to look almost directly into the sun for at least the first inning or two. It also means that, if you can get there early, there is amazing light during the pre-game field maintenance and team warm-ups. (It also

> "For me, the noise of Time is not sad: I love bells, clocks, watches—and I recall that at first photographic implements were related to techniques of cabinetmaking and the machinery of precision: cameras, in short, were clocks for seeing, and perhaps in me someone very old still hears in the photographic mechanism the living sound of the wood." – Roland Barthes

doesn't hurt if you have a good relationship with the great staff at the park, so that the ground crew ignores you as they go about their business.)

As you can see in the outtakes *(below)*, I have really worked this situation over time and multiple visits, waiting for certain moments, or great light, or working to use the graphical qualities of the stadium to my advantage.

▼ Some outtakes from shooting at the stadium. The center image, with the crew member driving the mower and dragging the field, was my favorite for a while. I like how the dust gets kicked up in the evening air and provides separation between the subject and the background. But while there is some very strong energy in the bottom right of this image, my eye goes up in to the sky and never comes back into the frame.

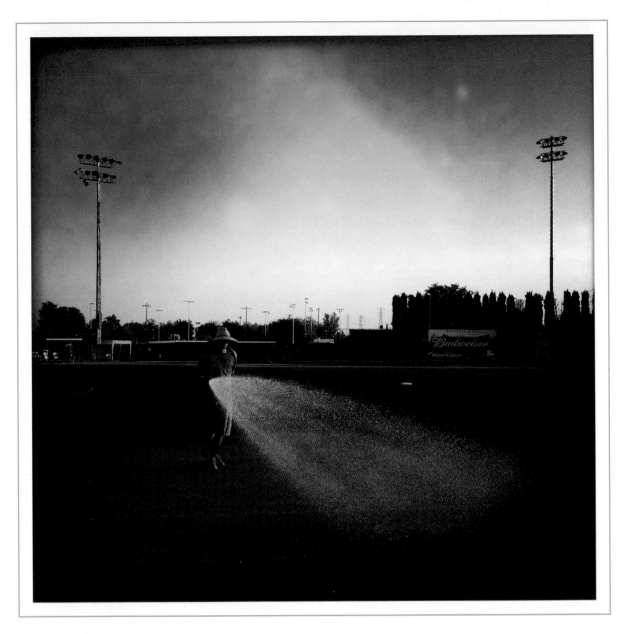

## About This Image

In the main image *(above)*, I really like the subject spraying the water into the shadows on the field. The sidelighting helps the spray of water pop out from the background. I like his body language as he sidesteps—and it doesn't hurt that he's wearing an orange shirt. That little spot of color goes a long way. The two light poles framing the image also really help the overall feel. While my eye goes up to the sky, the arc of the blue combines with the poles to help keep me in the frame—and then the light hitting the water from the hose brings me back down into the frame. (Compare this to the center image from the outtakes on the facing page; it is, perhaps, a subtle difference—but, more often than not, those subtleties are what's important.)

The image was shot with Hipstamatic, using the John S lens and Blanko film settings.

# 41. Water Engineer

### The Kelvin Filter

This is another early image that I still like because the Instagram filter Kelvin really lends a nice timeless quality to the photograph (*facing page*). The solitary figure standing in boots at the side of a stream is poignant for me and makes me think of the childhood adventures I used to enjoy. I also get a little hint of *Winnie the Pooh*; it is probably the boots that do that for me. Like many other filters, Kelvin can get overused—but here it really sings. I shot the image in Hipstamatic with the John S lens and Blanko film settings.

### Location

The location is one of the better kept secrets in the south end of the San Joaquin Valley, the Wind Wolves Reserve. It is the fastest place that we can get to for a hike from Bakersfield. There is not a lot of foot traffic and there are some amazing views of the mountains and the valley.

### Composition

Compositionally, the image works with a diagonal from the bottom left of the frame through the middle and following along the

> "You can look at a picture for a week and never think of it again. You can also look at a picture for a second and think of it all your life." – Joan Miró

road to the background. There is almost an X shape as the secondary road comes in from the left and both elements help frame the solitary subject just off-center in the frame. The trees on the left and right help provide a natural frame for the image, keeping our eyes from exiting up to the lighter part of the image in the center and helping pull the eye back down into the frame.

Take the time to learn to think about how your eyes move around a photograph. Hold a picture up and then pull it down and then lift it up again, until you can get a sense of where your eye is staring. Think about where your eye goes as it wanders, intentionally or not, around the frame. Usually, students and interns stare at

▼ Some outtakes from the same location.

me like I am crazy when I try to get them to do this—but, after a time, you can start feeling how your eyes are moving through the composition.

This is a particularly helpful skill to have when editing in-camera and trying to get a feel for what to add or subtract from an image. It's partly why folks stress composition guidelines; however, I think those kinds of folks want rules to follow, no matter what. Learning to get a sense of how your eye moves is the best way to help you make and frame interesting compositions, in my opinion.

# 42. Dock Dreams

Right after railroad tracks, docks may be one of the most popular subjects for photography. We can probably imagine all the reasons why—the receding lines of the dock as it moves through the frame, the fact that it ends (usually) opening up to water, and the nice tonal contrast between the deck and the water. All these things make it fairly easy to move the viewer through the frame.

## Playing with Light and Composition

As you can see in the images below, photographing at different times of day and in changing lighting conditions really affects how we "see" the structure. You can also see the changes that the composition makes when the horizon is at the one-third *(left)*, middle *(middle)*, or two-thirds *(right)* position. You'll see that I was also playing with symmetrical and asymmetrical compositions, both of which can make an image work. By showing this series, I hope you can see how I was thinking visually as I worked the light and the dock. It can seem frustrating or pedantic to photograph the same composition at different times of day, but you can start to see the difference on the editing "table."

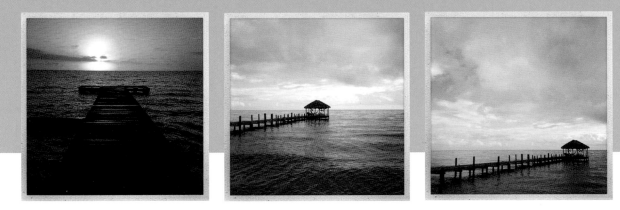

### Land and Sky

To me, docks are all those things *plus* the magical transition between water and sky. Nature photographer Galen Rowell first brought this concept to my attention and, ever since, I have enjoyed making photographs at these intersections—maybe because the other transitions in life are much less clear.

### Shooting and Composition

The image that most speaks to me *(facing page)* was actually photographed in the middle of the day with flat light. I think that the flat lighting makes the boundary between the water and the sky smoother than in the other images; the aqua of the water and the cyan of the sky blend visually. I shot this in Hipstamatic with the Jane lens and Ina's 1982 film settings. It was processed with Instagram's Lo-Fi filter.

It is an asymmetrical composition, although I think the cloud balances out the dock with its size compared to the visual mass of the dock. Photographers can get into trouble when they try to balance "heavy" objects with "light" objects in the frame. This is because the viewer brings, even subconsciously, knowledge about the real world to looking at images.

### A Flaw?

Yes, I know, the horizon dips a bit on the right of the frame (one of my photography mentors, Greg Dorsett, probably jumped up from his chair seeing this). This was an intentional decision; I tried the composition both ways and this is how the dock looked "right." Navajo artists intentionally leave a flaw in their work because only the Great Spirit is perfect. I am not saying that I am either—but I want to point out that the small flaw does not detract from a larger image that works. It's just another time I ignored one of those photography "rules."

> "The Earth is art, the photographer is only a witness." – Yann Arthus-Bertrand

# 43. Palm Trees

You can't live in California and not photograph a palm tree from time to time. I think it might actually be a statute somewhere. Californians love anything green that sticks up into the sky—even fake-tree cell phone towers. (Okay, well, maybe not the cell phone towers.) I think I like palm trees especially because they remind me of Dr. Seuss trees—particularly when silhouetted against a setting sun. I believe this is the only direct sunset in the book and even at that, the sunset is a supporting character to the trees.

## Evolution of the Image

Looking at the outtakes, you should see that I contemplated four trees at one point *(bottom left)*, but that composition was just not as successful. There is too much dead space in between that fourth tree on the left and the other three, and the bottom shrubs carry too much visual weight. Even the original image

*(bottom right)* needed a crop to really focus our eyes on the three trees. By tightening the frame on the left and taking off the body of that smaller palm tree on the right, the image became about the three main trees that are mirrored by three shrubs at the bottom of the frame *(facing page)*.

## Shooting and Processing

I shot this image in Hipstamatic with the Jane lens and Ina's 1982 film settings. It really

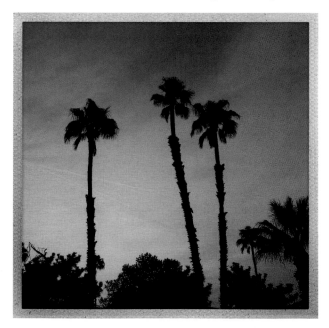

needed the extra color saturation from a visit to Filterstorm and then the Lo-Fi filter in Instagram to add some slight vignetting and finish off the image. The higher-contrast look is much closer to what my eye saw that night, minus the vignette. That darkening of the edges, a darkroom technique of old, helps keep the viewer's eye in the frame. I really like how the contrast makes the detailed edges of the palm tree trunks pop in the photograph. In my mind, I am waiting for the Lorax or a Who to walk through the frame, possibly humming a song that rhymes in couplets.

# 44. Moment

This is one of my earlier images that really allowed me to grasp what could be done with a camera phone *(below)*. I saw the strong color field as I was grabbing a cup of coffee in an airport on my way to a meeting and really liked the strong silhouette of my subject's head against the window light. A tighter crop worked better for me, so I quietly moved forward to make an image—my coffee left behind me somewhere. Using the Hipstamatic

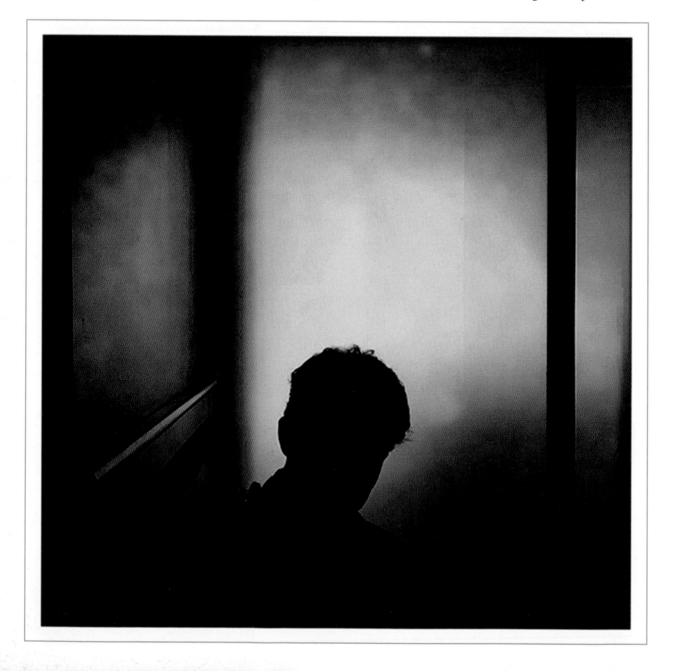

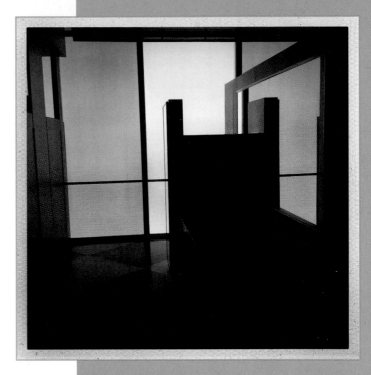

app, I shot it with the John S and Blanko film settings.

## The Role of Observation

For some reason, this image makes me think of the double-slit experiment in physics. For those of you who are not physics geeks, bear with me (this is how my mind works . . . or doesn't). When scientists shoot photons through two slits, they encounter a very interesting pattern: when the photons are *observed* going through the two slits, they behave like particles; but when the photons are *not observed*, they behave like waves. Confused? I am, too.

My take-away from this is that the very act of observing the experiment changes/impacts the experiment. Just like physics, the act of photographing the world changes the world, even if just slightly. For me, that means every knowing or unknowing interaction I have with people and with the world has an impact, however small. Some people don't consider themselves that special or worthy of being photographed. The very act of asking them, before or after I make the image, might change how they think of themselves.

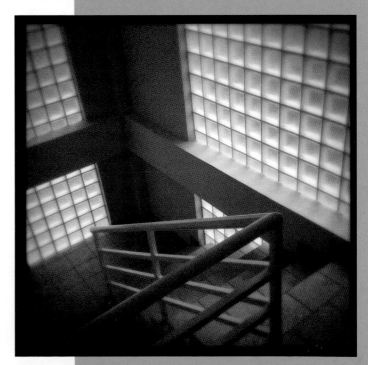

▶ I am attracted to graphic, grid-like images; that is just the way my eye appreciates the world. When colors and strong shapes start working together, my mind starts calculating how to capture the moment.

# 45. Crashing Waves

When we're on a family vacation, sometimes all I want to do is *not* pick up a camera—this was a day when I felt like going out and making images. My brother decided to go for a run, and I opted for a walk along the ocean. Little did I know that things were about to get very interesting and that I was about to strain my phone's hard drive and battery. Such is life!

It was a wonderful late afternoon along the Pacific Ocean, an embarrassment of riches for a photographer, and yet I was the only person out there making pictures (I'm not complaining). I really wished I had grabbed my DSLR before heading out, but by the time I had found what I wanted to photograph it was too late to head back. I decided to work with simpler equipment and my feet.

> "Photographers tend not to photograph what they can't see, which is the very reason one should try to attempt it. Otherwise we're going to go on forever just photographing more faces and more rooms and more places. Photography has to transcend description. It has to go beyond description to bring insight into the subject, or reveal the subject, not as it looks, but how does it feel?" – Duane Michals

## Shooting . . . a Lot

I will be honest with you, I burned a lot of pictures to get this one image *(facing page)*. According to my frame numbers, it took over forty images to get this one photograph. Fortunately, as my first supervisor used to say, pixels are free.

As I will often say in class or while working with one of our interns, it is like shooting free throws: the more you do every day, the better you will get. In this case, the farther out on the

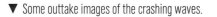
▼ Some outtake images of the crashing waves.

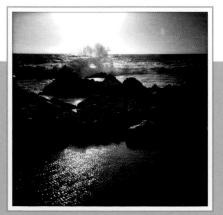
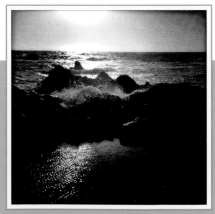

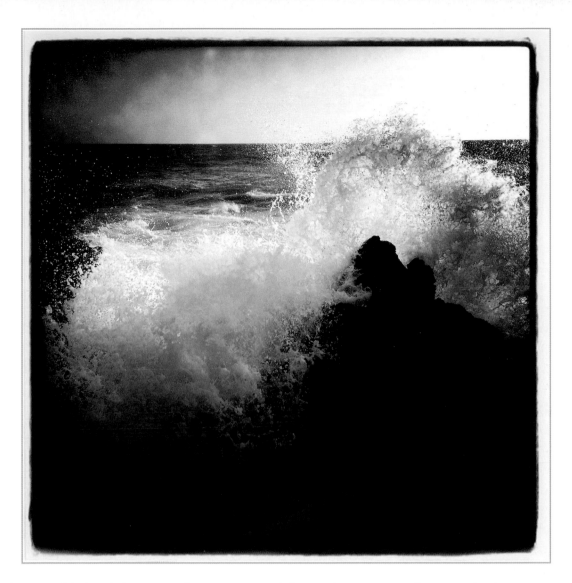

wet rock I scrambled and the more often I re-composed, the better I got at anticipating the wave sets—and the lower the sun got, the better my chances were of making a photograph that I might want to keep.

## Get Close

One of the comments you might hear in a newsroom is that if your pictures were not good enough, you were not close enough. In this situation, that was spot on. Climbing out onto a rock formation was the key to getting a good shot—yes, I was wondering how well my phone might weather sea water, but I was having too much fun making pictures to really worry.

The final image works on a number of levels, including the backlighting of the wave, the very Japanese painting style of the wave's edge, the rock in the foreground, and the ocean in the background. The image just says "waves crashing!" for me—but it says it well and I made it with my phone. I shot the image with the Hipstamatic app using the John S lens and Blanko film settings. In Instagram, I processed it with the Lo-Fi filter.

# 46. Love for Thanksgiving

My friend Brandon has this vision of making sure people get fed on Thanksgiving—and he has a heart big enough to motivate a portion of a city to go out and do just that. Last year, 40,000 meals were assembled and distributed around Bakersfield, CA, and this year there were 60,000 meals supplied. When I first started documenting things, everyone could meet at a large garage in town; now they need a parking lot!

### Video Plus iPhone Stills

For the last two years, I have been shooting video at this event, so I tend to use my phone camera for still documentation while my other camera is rolling on video. This photograph (*facing page*) conveys a good sense of the spirit of community when 3,000 people gather to help feed others. It is just a quiet, fun moment between a father and his son, but it says so much about the day.

### Shutter Delay

I have found that the slight delay on the phone camera is a little frustrating to a photographer used to anticipating action and using a DSLR.

> "When I look at my old pictures, all I can see is what I used to be but am no longer. I think: What I can see is what I am not." – Aleksandar Hemon

### Rewards

Taking the time to do this – and let's be honest, all I am doing is documenting things; everyone else is doing the work – makes my Thanksgiving dinner taste that much better. When I sit down with family and friends at the end of a long day, I am glad that I got up before sunrise and documented one of those days where I am really proud of my city and many of its citizens.

Thankfully, this was a repeated moment between father and son, so I had plenty of frames to get the image I was looking for. With Hipstamatic, I used the Jane lens and Ina's 1982 film settings. I finished the shot with Instagram's Lo-Fi filter.

▼ Additional Thanksgiving images.

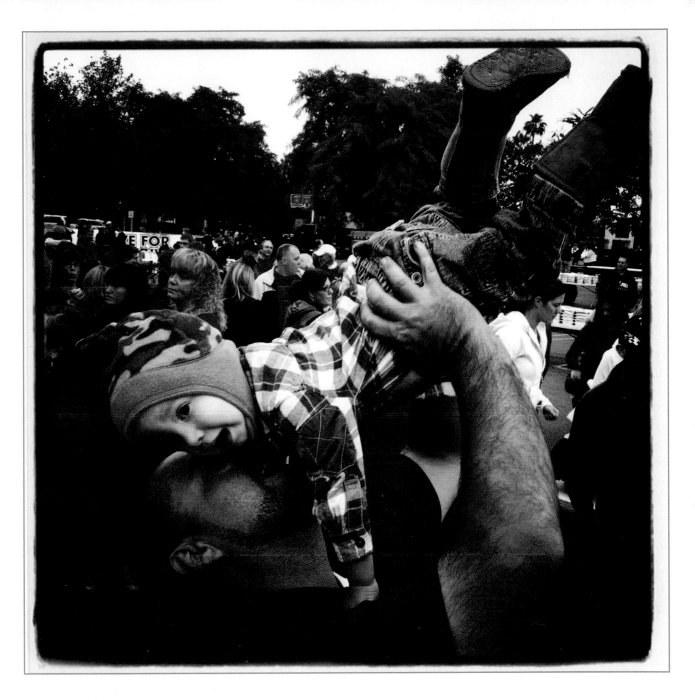

## About This Image

I don't mind the slight tilt in the horizon; it gets me more of the little guy's boots in the frame. I really like the expression on his father's face as well as the background full of people in the parking lot. It makes this more than just a nice feature photograph of a father and son.

Even the fact that the little guy is wearing a long-sleeved shirt lets you know it is the fall or spring. You can tell it is California because Dad still has short sleeves on.

# 47. Chess

I already talked about Dagny's in section 39. One of the many things I like about the shop is the interesting and strong lighting at different times of day. Giant windows let light pour into the shop, bounce light onto the outside seating area, and modulate the morning sun inside in the most wonderful ways. As photographers, we are constantly searching for, playing with, and utilizing the light—be it naturally occurring, a reflection, or man-made. Lighting helps set the mood of the image.

## Shadows on a Chess Board

Light gives shape, and strong, angular lighting creates shadows. In this image *(facing page)*, I really like how the shadows begin to overlap to create different shapes at the bottom of the frame. I also like how the white pieces seem crowded and confused while the brown pieces seem more orderly and less hectic (yes, I realize the brown shadows fall off the board).

However, it is the human hand coming into the frame and starting the game that really works for me. I like the human element—the worn chessboard, the young-looking, small hand, the wood pieces, and the modern

> "A successful photograph raises these questions. It does so without resort to the vocabulary of the literary language, returning us back to the source and impulse of all life."
>
> – Robert Leverant

patterned coat all vibrating and bouncing off of each other. It looks as though our subject is opening with a pawn . . . one or two spaces?

Chessboards are metaphors for so many things that a list would only come up short. This image suggests a lot of possibilities—but perhaps this one does not need to be fully explained. As Iris DeMent sings, "I think I'll just let the mystery be."

In Hipstamatic, I shot this with the Loftus lens and Ina's 1982 film settings.

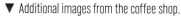
▼ Additional images from the coffee shop.

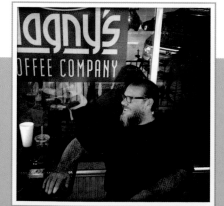

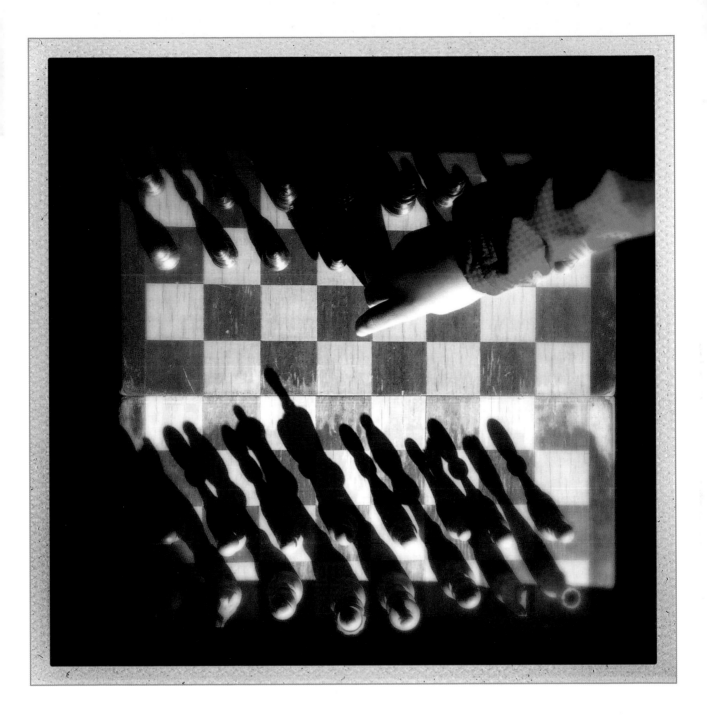

❝ I like the human element – the worn chessboard, the young-looking hand, the wood pieces, and the patterned coat all vibrating and bouncing off of each other. ❞

Like most photographers, I enjoy making pictures in the early morning. Let me rephrase that: I enjoy *using morning light*. I don't like having to get up early to do it. At morning, the quality of the light is different from sunset and, at least in California's San Joaquin Valley, the mountains are not too high and the view is fairly unobstructed.

## The Last Sixteen Miles

My wife had been working to support a pilgrimage of eleven walkers from Sacramento to Bakersfield, and I found myself with an opportunity to walk the last 16 miles of their travel. As I was getting all my equipment ready in the darkness, at 5AM near Shafter, the group gathered together to discuss the day ahead. Having taken part in support of other walks, I thought I was prepared—silly me. The pace this group set was a quick one that I think I could have maintained with some practice . . . and if I had not been walking ahead of them to get into position to make pictures and then running to catch back up. For the first part of the morning, I probably walked and ran twice what everyone else did.

"Taking photographs is a means of understanding which cannot be separated from other means of visual expression. It is a way of shouting, of freeing oneself, not of proving or asserting one's own originality. It is a way of life." – Henri Cartier-Bresson

## Isolating the Subject

After trying to frame groups of walkers, I finally decided that it was going to be easier to work with the composition and the sun if I concentrated on one person. Fortunately, some folks were wearing reflective vests—and this subject (*facing page*) also carried her rosary and a poster of Our Lady of Guadalupe the entire distance of the pilgrimage.

▼ Initially, I shot groups of walkers (left and center). Then. I concentrated on one subject (right). I cropped this frame to produce the more dynamic composition in the final image on the facing page.

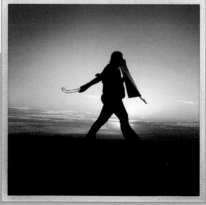

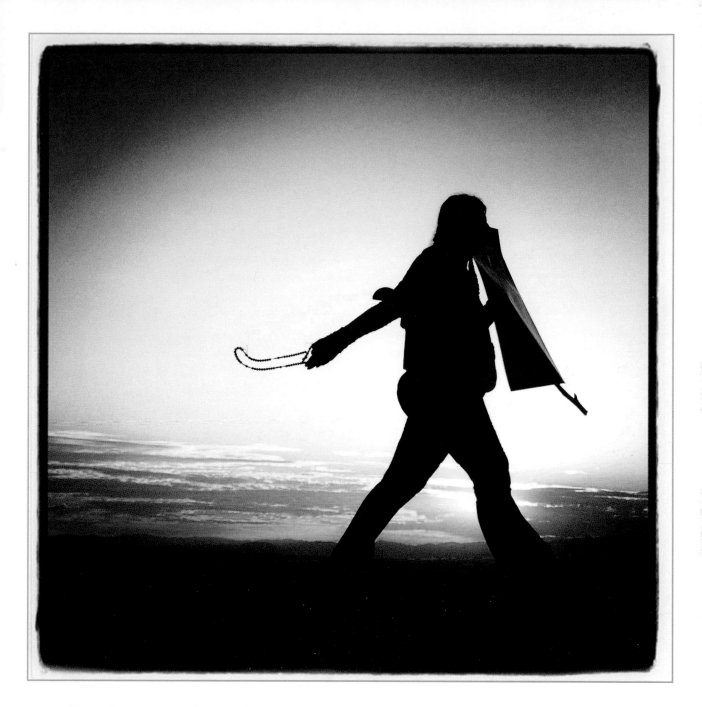

From there, it came down to body language and working with the rising sun. As you can see, the original is cropped looser and is a weaker image. The crop with her appearing to walk out of the frame is stronger; the stride and sun hidden behind her right leg adds energy to the image—and it is a very active image. In Hipstamatic, I used the Jane lens and the Ina's 1982 film settings. I also applied the Lo-Fi filter in Instagram.

This is an interesting photograph, but there is a good story behind it—and it is more than just a straight news or documentary image.

# 49. **Pilgrimage**, Part 2

### Arrival

Right on schedule, the pilgrims arrived at the Congressman's office that was their destination. (Fortunately, I had a clean shirt packed in my camera bag because I had really been sweating the last five miles and there had not been a lot of shade.) Outside the office, the group and supporters held an event where people talked, prayed, and gave speeches. It was an emotional event that I could certainly sympathize with after just walking one day. That being said, it was difficult for me to capture the scope of the day and event with a photograph of the people or their tears.

### A Symbol of the Journey

What wound up catching my eye and attention were the sneakers that the pilgrims left outside the Congressman's office in front of the makeshift altar with a poster of Our Lady of Guadalupe in the background. Most of these shoes had made the entire journey, so there was meaning attached to them—along with the dust

> "A camera is an extension of ourselves. An appendage to bring us closer to the universe." – Robert Leverant

and dirt from the valley and their walk. It did not hurt that there was an American flag blanket in the background. It adds more context and nuance to the photograph.

By getting as low as possible, putting my phone on the ground, I was able to give the sneakers the prominence and importance of the foreground position. The poster and simple cross, when combined with the altar and the shoes, start asking some interesting questions as well as making some challenging statements—which is what, I am sure, the pilgrims intended. In Hipstamatic, I shot with the Jane lens and Ina's 1982 film settings. In Instagram, I applied the Lo-Fi filter.

### An Ongoing Story

There is something to be said for the pilgrims' walk and efforts—as well as their eloquence

▼ Different compositions of the shoes (left and center). I cropped the image on the right to produce the final image on the facing page.

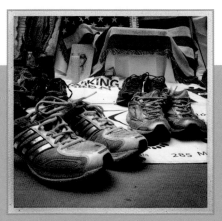

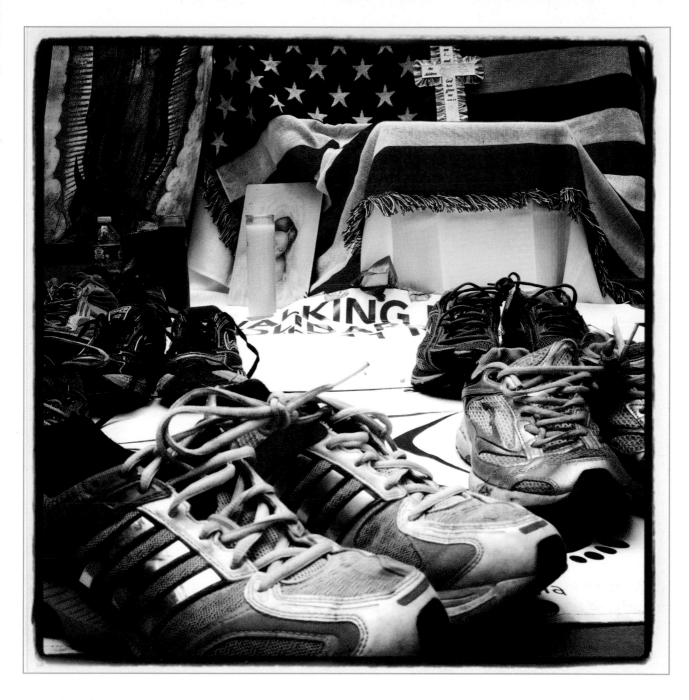

and media savvy. It was a long, hot, wonderful, tiring day—and carrying all my gear to shoot stills and video plus capture iPhone images made for an early bedtime and blisters that lasted for a while. Recently, I ran into one of the pilgrims at a favorite restaurant of ours and he was quite pleased to see this image (and the previous one) on the back of my business card. The story is still getting told.

# 50. Parade Rest

### Less Is More

There are so many times in photography when less is more—when what you subtract from the frame is more helpful than what you add. Some people call this the "KISS" principle, an acronym for "keep it simple, stupid." Here's another way to put it: don't overthink things.

### The Occasion

Bakersfield's High School Air Force ROTC cadets and student body were there to pay their respects as the remains of Pfc. Roosevelt Clark and his honor guard drove through campus. Pfc. Roosevelt Clark had attended the school and then fought in the Korean War and, finally, was being returned home to be laid to rest. The honor guard was running late, which gave me time to photograph and line up where I wanted to be when they drove on campus.

### Photography

As you can see from the edits presented below, I tried to work the situation as best I could, utilizing the repeating shapes of the cadets,

> "There is one thing the photograph must contain: the humanity of the moment. This kind of photography is realism. But realism is not enough—there has to be vision, and the two together can make a good photograph." – Robert Franklin

standing at parade rest, along with their shadows. I even tried pulling out the D-Type Plate film effect *(below, center)*, hoping that maybe it would help with the photography or composition.

Finally, this one cadet with great posture, posed strongly in the shadow of a pole, started to stand out for the composition. The negative space of the road, his posture, the way the slope of his hat mirrors the converging lines of the road—it all works to make the photograph successful. I particularly like the spot color of his hands clasped behind his back.

I shot the image in Hipstamatic with the Lowy lens and Ina's 1982 film settings. The

▼ Different compositions of the parade.

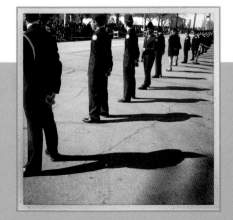
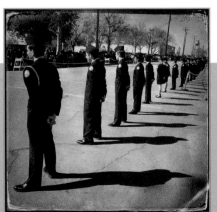
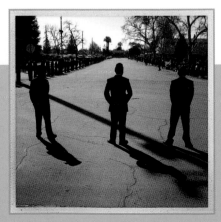

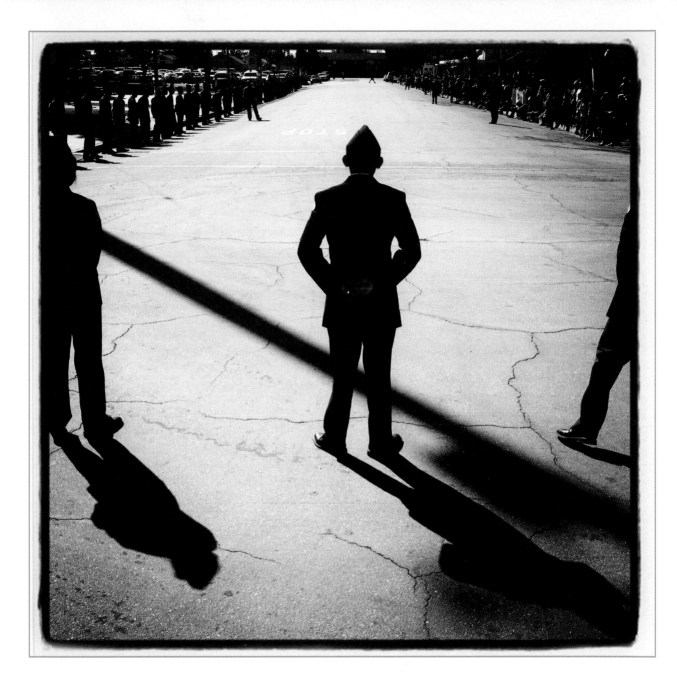

Lo-Fi filter added contrast and a border. I also cropped the cadets to either side of the subject, helping focus your eye more on the composition's strong graphic lines. The shadows in the foreground really help balance things out and give a nice foreground, midground, and contributing background to the image.

66 Finally, this one cadet with great posture, posed strongly in the shadow of a pole, started to stand out for the composition. 99

# 51. Forehand

By this time, you and I are probably *both* getting tired of the "John S lens and Blanko film" combination I often use in Hipstamatic. The argument that I will make for using a consistent combination for a period of time is that you start to learn what it can do in a variety of situations. The flip side to that argument is that you can get trapped in a rut or just see the world in the same way. When I first started using the Hipstamatic app, I generally stuck close to the same lens and film combinations until I had a lot more comfort personalizing the system. It helped me get a better sense of the breadth I could achieve with the different combinations.

### Out on Assignment

I think this tennis tournament was the first time I used the iPhone out on a sports assignment— in addition, of course, to my DSLR and a long lens. The image I edited and posted to Instagram *(facing page)* was meant as a tease for the next day's newspaper, but it was fun to work with both my camera phone and my newspaper-

issued camera gear. I can't tell you what image I made with my conventional gear, but I still enjoy this one.

### The Right Perspective

The most critical step for making this image was getting some perspective on the court. Fortunately, the Bakersfield Racquet Club has a gallery that provides a different way to photograph or watch the matches. Next, I started playing with the graphic lines of the court and the color of the surface, as well. I experimented with one other film setting but went back to the combination that I liked for this situation—remembering, as the song says, that it is better to "dance with who brung ya."

The body language of the athlete is dynamic. The viewer can anticipate the arrival of the ball and the stroke that is about to happen.

▼ Different compositions shot at the tennis court.

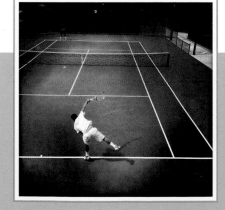
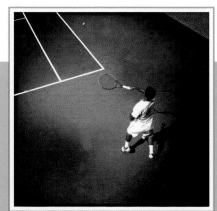
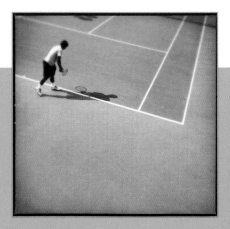

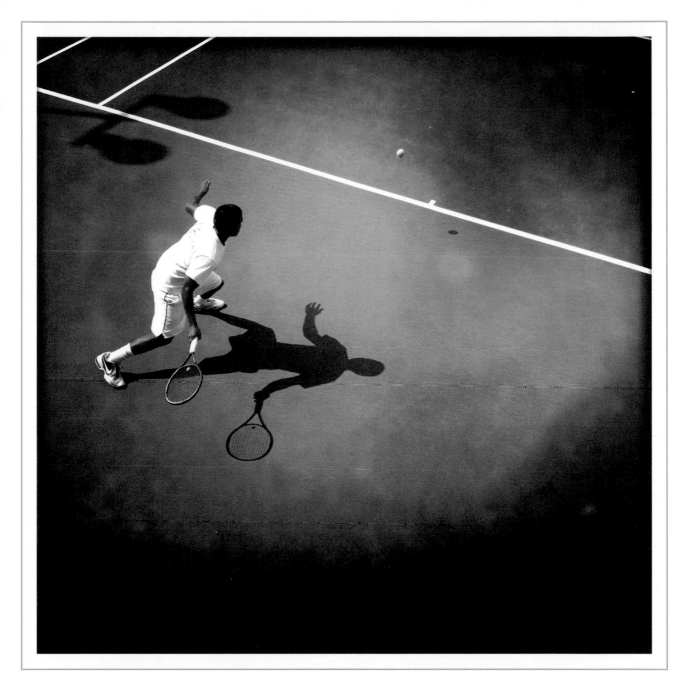

The white line is a helpful diagonal, and I like that the ball is floating over the blue surface while its shadow is over the green part of the court.

When I look at the outtake images and the main image, the editing choice is very simple.

At the risk of quoting Michael Williamson from *The Washington Post,* sometimes with a photo that works all you need to say is, "It works."

# 52. Bike Corral

I created this image *(below)* while helping a friend shoot a public safety announcement about road bike safety. The area we scouted out to shoot in ended near a cattle chute, and this became a perfect place to park his bike while he drove my car and I shot video from the passenger seat. When we were done working, this image of the corralled bike just called out to be photographed.

## Another Hipstamatic Effect

The Tinto 1884 lens effect can be very helpful in softening the edges of the image and adding some mystery. It softens hard details that might

take the viewer out of the moment. I want the viewer to be looking at the subject: the bike. For some reason, I also think keeping just one section of the wood in focus helps me to enjoy it more than holding everything in the frame in focus. An extreme arc of focus lets the photographer hold the viewer's eye in the frame with the focus and softness. Of course, use this technique too much and you run the risk of becoming a one-trick pony. I really try to do things like this infrequently so that, when it works, folks aren't looking at the technique, they are focusing on the photograph.

## A Few Other Looks

For the image on the facing page, I used Hipstamatic's Ina's 1982 film setting. A version I made with the C-Type Plate film setting *(center, right)* is probably my second favorite in the outtakes. I like the visual discord between the high-tech bike and the old cyanotype look. I generally find the Tinto lens with the C- or D-Type Plate to be too much "effect" layered onto the image. That doesn't mean it doesn't work from time to time, but I really like keeping the image more in focus when using the C- or D-Type Plate film settings. When using the Tinto lens to blur, other film styles most often work better.

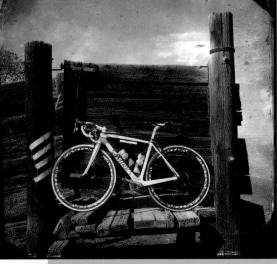

"While there is perhaps a province in which the photograph can tell us nothing more than what we see with our own eyes, there is another in which it proves to us how little our eyes permit us to see." – Dorothea Lange

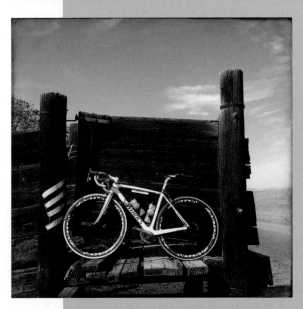

▶ A few different approaches to shooting the same scene.

# 53. High School Campus

One of my favorite sequences from the television show *Joan of Arcadia* was when God, as a cute boy, was talking to Joan and trying to prove his divinity.

> Joan: Let's . . . let's say you're God.
> Cute Boy God: Joan, I am God.
> Joan: Okay, well, let's see a miracle.
> Cute Boy God: Okay. How 'bout that?
>
> (The camera pans to a large tree nearby. Cute Boy God stops beneath it.)
>
> Joan: That's a tree.
> Cute Boy God: Let's see you make one.

## The Beauty of Trees

Trees are just really amazing things to look at; the problem is in trying to photograph them well so that you can tell it is a tree and still keep it visually interesting. In the photograph on the facing page, I think it is the concept of "trees" that is coming through—perhaps more than just "one tree." I like the two palm trees framing the sun, but I also like how the sun is peeking through the smaller tree and illuminating part of the grass and the line of cars in the bottom right of the frame. I shot this image on the Bakersfield High School campus.

## A Nice Surprise

I shot the image in Hipstamatic with the Jane lens and Ina's 1982 settings. What is very interesting to me is how the overall tone of the image affects the Kelvin filter in Instagram and gives it a nice teal/cyan tone that I don't often see with that filter. It is fun when I get surprised by things—even these days. It is important to see what is in front of us as well as to hold a vision of what could be.

## Learn to Listen

How I am going to work with an image usually becomes obvious if I listen to what it is telling me it wants to be. More often than not, when I try to do too much to a photograph it rebels and fights back—I just have to listen.

I began a series on creativity because I had a hard time explaining to my wife how the work tells me what to do with it. When you try to do

▼ Trees make amazing subjects for photography.

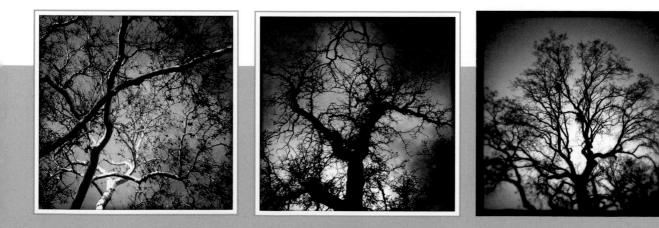

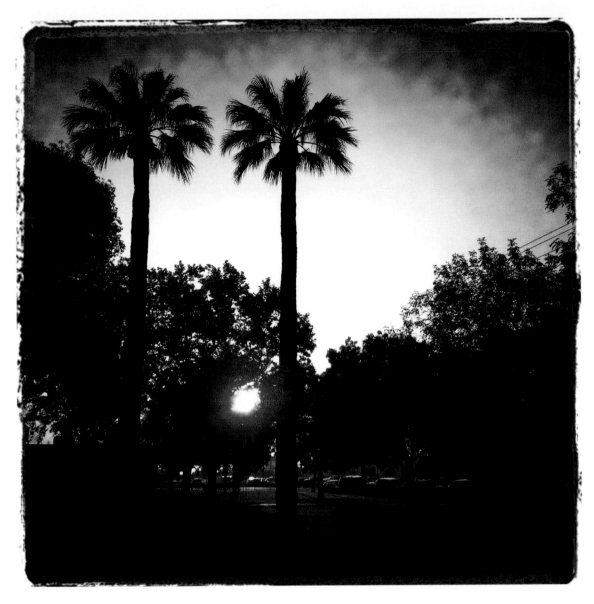

too much, it starts to look fake and it loses the truth that existed in that moment. It starts to die in front of you, so you have to pull back or try something else.

What you want to avoid is having to throw that image on the pile of "almosts," images that were almost good—almost the right moment or almost the right perspective. I am not haunted by the "almosts," but they push me to get better, to get it right, to keep exploring, and to follow where my work wants to go. It can be uncharted territory at times, but that is usually where you make the biggest breakthroughs— when you are looking for something else.

> "I am a professional photographer by trade and an amateur photographer by vocation." – Elliot Erwitt

# 54. Concrete Ghosts

As I tell my students, you have to be smarter than the camera all of the time—even though it is generally smart enough most of the time. In situations where the camera opens up or compensates for exposure, the photographer has to step in and retake control. Because I was making this image with my camera phone, which has such limited control options, I needed to do that work in postproduction.

> "To sum up, if you want to be more creative, start loving yourself enough to give yourself permission to fail. In fact, better yet, don't even worry about winning or losing. Just DO."
>
> – Scott Bourne

### Shooting and Postproduction

I was waiting for a taxi with friends in Newark when I saw our shadows cast on a concrete wall by the setting sun. My first take of the scene was with the Hipstamatic app, using the John S lens and Blanko film settings *(bottom left)*. Our shadows did not have the richness of what I saw with my eyes or where I thought the image could be pushed. The next step was to open up the image in the Filterstorm app to desaturate the photo and increase the contrast *(bottom center)*. From there, I opened the image in the Noir app to add the cyan cast as well as the vignetting *(bottom right)*. Finally, I brought the image into Instagram and finished it with the Lo-Fi tone to increase the contrast and add the simulated full-frame printing border *(facing page)*.

### On Processing Images

This is probably the most processed photograph in the book because what my eye saw and what the camera recorded were so far apart. My work is generally much more about seeing the moment, anticipating what people might do or how things might play out, and getting

▼ The inital exposure.

▼ Image processed in Firestorm.

▼ Image processed in Noir.

into position to capture it. In one sense, I think that is a strength of most of the images in this book—most anyone could make them with the same equipment.

Occasionally, though, a little voice whispers in my ear that there may be something here if I work a little harder, dig a little deeper, and utilize all those skills I have learned over the years and with different apps. I am not telling you to run out and spend lots of money on lenses or add-on features. It is all about that critical space between your ears and knowing what your equipment can do.

It is a very liberating experience and helps me regain that rush I used to experience when I first started making photographs, and then when I got better, and finally when I really started to grow quickly. All too often, when you start exchanging images for money or security you lose that feeling. It is so good to have it back in my life and my work.

# 55. Mt. Pinos

Our family loves to hike, and Mt. Pinos is within easy driving range. Usually, though, we do not get cloud coverage like we did on this day. As a result, I took so many pictures that my phone battery died in the cool, crisp air. So I did what any good photographer would do: I borrowed my wife's phone.

### Silhouettes

In this simple, fun photograph *(facing page)*, I like the shapes and multiple tones of the clouds, the tree on the left mirroring our subject's gesture, and then the soft rolling mountains on the lower left of the image. The extra contrast really helps with the silhouetting and cloud detail information. Again, shooting into the sun paid off with the right composition. The foreground did not provide enough information to be included and pulled away from the mountains in the distance. I shot the image in Hipstamatic with the Lowy lens and Blanko BL4 film settings. In Instagram, I used the Lo-Fi filter.

> "Stories are one of the greatest gifts we can give to our children. Stories are equipment for life." – Matthew Knisely

### A Side Story

This trip included a number of firsts for our foster daughter. She utilized a mountain privy a few times—and on her last trip, she found $10 caught in a shrub on her way back to the trail. We assured her that would probably never happen again, especially on top of a mountain, and suggested that perhaps she treat us to a snack on the way back home.

Naturally, the person with the shortest legs got tired and I carried her most of the way back down the mountain. I kind of expected that to happen, seeing how much she ran at the top of the mountain and that it was her first hike of any distance at minor altitude.

We learned a lot about each other on that trip and, once again, I got lost in making images while hiking—something that helped lead me to professional photography many years ago.

▼ A few variations from the same outing.

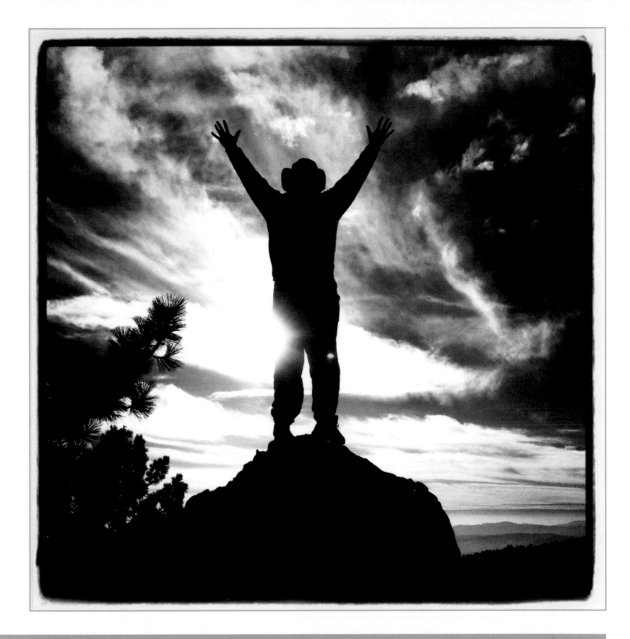

## Experimenting with Another View

In these tree images, made on the same day, you can see that shooting with the sun behind me (left) brought up some interesting details in the wood – but these did not have half the interest of the sky. When I started using the sunlight as an edge light on the tree it helped (right), but the clouds in the eastern sky just did not have the strength of looking west.

# 56. Flex

You guessed it, we are just down the walking path from Muscle Beach in Venice—just south of the Santa Monica Pier and fully in Los Angeles glory *(facing page)*. Where else can you find a middle-aged weightlifter with a small radio and ladies on roller skates?

> "I don't just look at the thing itself or at the reality itself; I look around the edges for those little askew moments – kind of like what makes up our lives – those slightly awkward, lovely moments." – Keith Carter

## Wait for the Moment

I was waiting for a friend, so I just sat myself down and patiently watched for the right moment. Our weightlifting friend had been talking with the man on the far right, who was trying to get folks to visit the establishment behind them, when our roller skaters came by. This gave me two solid subjects for street photography in a picture together.

The trouble was all the passersby. They added some energy to the moment but also obscured the key players *(left top and center)*. And check out the bottom-right photo. Every now and then a "people taking pictures" image works, but not here *(bottom left)*—our green-shirted friend ruined that moment. Finally, there was a gap in the foot traffic and I was able to grab the image that I wanted *(facing page)*.

For this image, I really wanted to accentuate the shadows and bump up the contrast because the photograph, taken with just my iPhone

◀ Some other shots I grabbed as I sat waiting for the right moment.

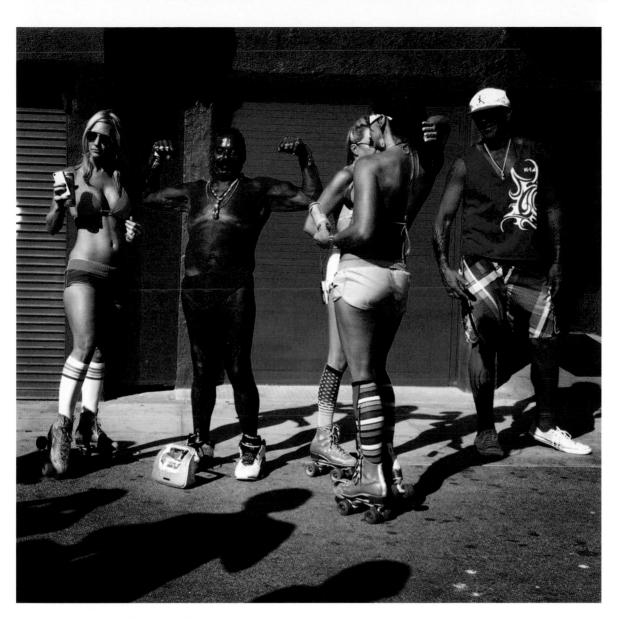

camera, was a bit flat. Adding the Lo-Fi filter in Instagram accomplished that. The color, the pose, and the outfits all scream Los Angeles and Venice Beach for me.

## Street Photography

Street photography has a long, interesting lineage that I will not attempt to condense for this book. There are different kinds and styles of the form—and there are remarkable practitioners of the form using camera phones.

Richard Koci Hernandez and Scott Strazzante are two whom I follow religiously. To me, it is all about the form, color, and moment—those moments that you might nudge your friend in the ribs and point out. But that, I think, is selling things a little short. Exceptional street photography holds up a mirror to life and humanity and causes us to take a second or third look and really think about what it is to be hairless apes, wandering around this planet.

# 57. Stacking Rocks

My sister-in-law became very interested in the work of Scottish artist Andy Goldsworthy and had the great idea to visit the beach and construct our own Goldsworthy-esque sculptures. (If you are not familiar with Goldsworthy, take the time to look at some of his work.) This led to a fun morning that the children, depending on their ages, either got very into or became very bored with and wandered off to do their own thing. My brother and his daughter worked on some very complex pieces together.

Please do not think that I'm trying to equate our designs with Goldsworthy's. We learned some valuable lessons about his work, including how deceptively easy it looks to do what he does. But I do like the idea of experiments with emulating someone's work. It was also refreshing to work in a different medium. It got me out of my comfort zone quickly and easily.

### A Sense of Place

I believe that the most successful images in this series give the viewer a sense of place—but without too many details that might take away

> "These are the two basic controls at the photographer's command—position and timing—all others are extensions, peripheral ones, compared to them." – David Hurn

from thinking about and exploring the shapes of the standing rocks. Some of the straight documentary-style photos worked well to illustrate our work that day, but they didn't convey a sense of the emotion or concentration of our efforts. Trying to include more than one sculpture in the frame also seemed to lessen the impact of the work.

It was fun to experiment with different film and lens settings as I worked away in the sun, the whisper of the surf in the background. For the final image *(facing page)*, I settled on the Tinto 1884 lens and Ina's 1982 film settings in

▼ A few different ways I documented our sculptures.

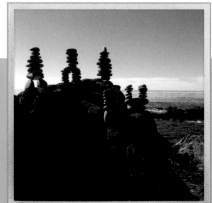
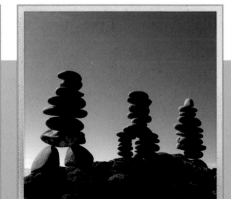
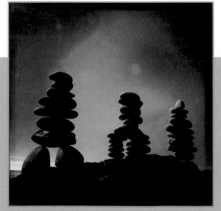

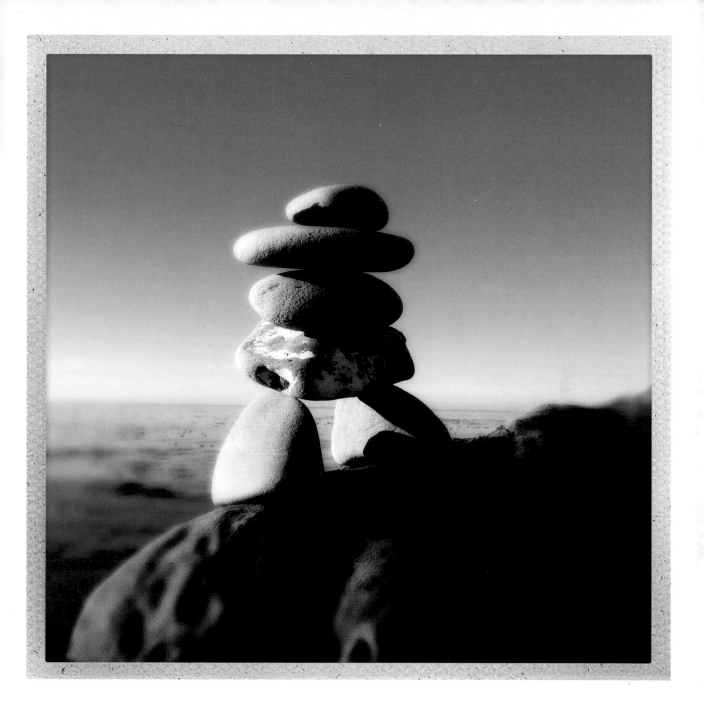

Hipstamatic. I also experimented with where to put the horizon, how much (if any) ocean to include, how much depth of field or focus worked, and what gave me the best sense of the coast we were on.

The obvious impermanence of the work made it all the more important to photograph the pieces well. Reportedly, the standing rocks did not survive the return of the ocean tide that evening. I think that was good news; these photos are now the only "proof" of our efforts that day.

# 58. Rift Valley

On my way to a meeting with a colleague about a documentary we were editing together, I happened to drive past this front-row seat to the San Joaquin Valley. I just couldn't resist shooting it, so I pulled my car off to the side of the road (safely) and then went back to make some images.

### Composition

I crossed the road and experimented with a few lens and film combinations *(below)* but couldn't make things work. You have to admit, it is a fairly boring composition.

So I went back to the side of the road where my car was parked and looked back at the chair—voilà! I had a much better composition that used the road and telephone poles to give depth to the image and provide more context for the chair being on the side of the road. Add in a passing red car and we have something to work with. Hipstamatic's John S lens really added some nice texture on this digital image that is a little more "out there." I shot the final image with the Ina's 1982 film setting, as well.

> "The hunter-gatherer mind is humanity's most sophisticated combination of detailed knowledge and intuition. It is where direct experience and metaphor unite in a joint concern to know and use the truth." – Hugh Brody

### Thought Process

Once again, here's how my mind works—I start asking questions. Who was sitting here? Did they move their seat or did they leave the room? What was happening in front of them? More practically, who would leave a chair on the side of the road? Why? And yes, I know, it is just a chair along the side of the road . . . but it could be so much more. It raises so many interesting questions, even if they are mundane ones.

▼ This composition was not as successful.

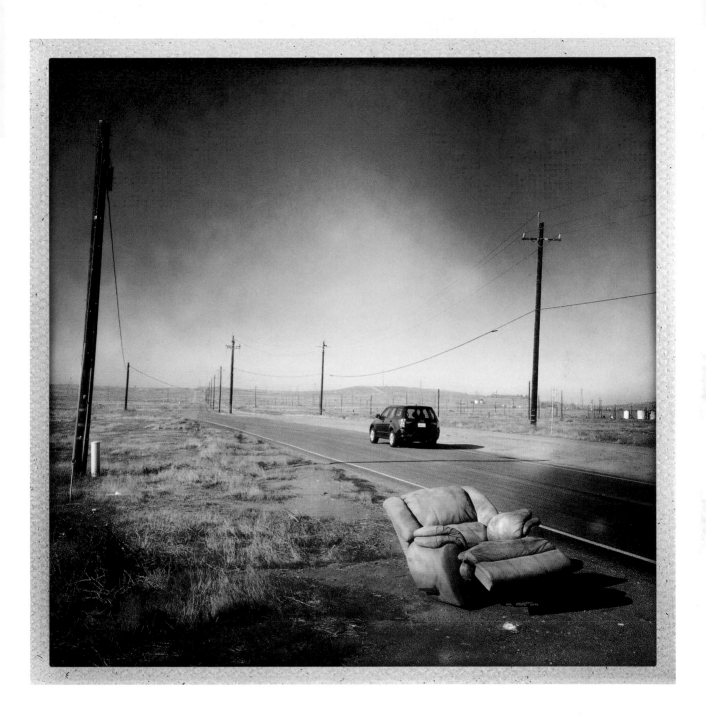

66 I had a much better composition that used the road and telephone poles to give depth to the image and provide more context for the chair being on the side of the road. 99

# 59. Trust Your Instincts

One of my biggest and earliest breakthroughs came when I stopped trying to be a "serious" photographer and let my sense of humor saturate my work. Once I stopped fighting with myself and let whimsical or outright humor into my photography, it began to open up other things in my work—and even my more "serious" images felt more comfortable and less constrained.

Too often, we photographers let our viewers, spouses, and editors influence our work; their voices in the back of our minds cause us to edit in-camera or not make a picture. Let that go. Don't listen to them. Intentionally make images that they might not approve of. Find and follow *your* vision. Do what you need to make it happen.

## Keep Your Eyes Open

On this trip to Lake Michigan, we walked out onto a jetty where other sunset-seekers were

> ❝ At sunset, the light gets wonderfully warm; when it can be contrasted against the blue of the lake and the water, we get a color theory 'home run.' ❞

congregating. However, it wasn't until I backed up, and the sun dipped lower to the horizon, that the magic started to happen. The clouds and the shapes really started to work and offset the strong shapes of the watchers' bodies. We had a hungry six-year-old with us so we started to leave before the sun had fully set—but when I turned around to look as we we were leaving, I knew I had to jog back to the end of the jetty.

## Zero In on Your Vision

One of the most underutilized pieces of equipment at our disposal is our feet. They are really quite an effective—and inexpensive— zoom lens. In this situation, I was looking for strong silhouettes and body language to make

▼ Alternate compositions of the scene.

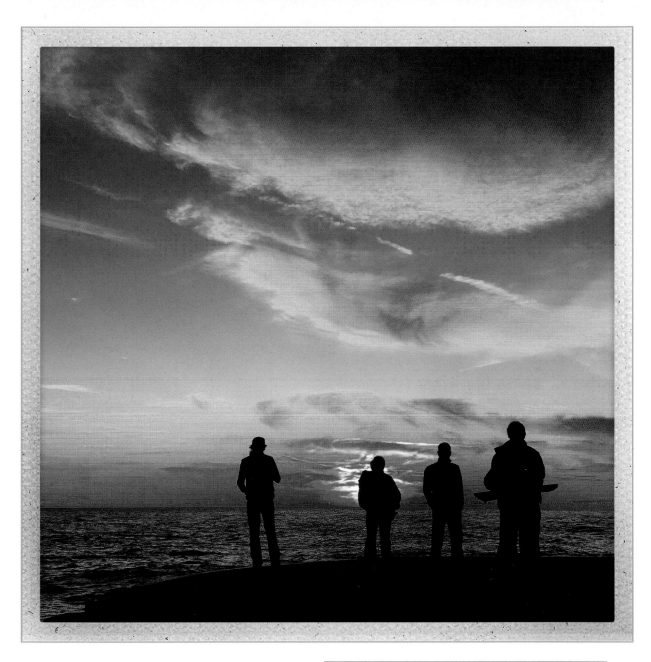

the image work. The extra images *(facing page)* illustrate how I visually "edited" the scene in-camera, working with what originally caught my eye and attention *(above)*.

## The Power of Sunsets

At sunset, the light gets wonderfully warm; when it can be contrasted against the blue of the lake and the water, we get a color theory

> "The camera basically is a license to explore." – Jerry Uelsmann

"home run." It is a time of day for dreaming—or hugging the loved ones we are standing next to on this spinning planet.

# 60. Personal Vision

I still remember a class called "Personal Vision" that professor Gunther Cartwright taught at RIT. All these years later, I am finally understanding what Gunther was trying to teach us back in our formative years. Students often spend more time copying other photographers' styles than analyzing their own body of work. (Although, quite honestly, I don't think many of us had a real body of work to examine at that point!) Now, looking at the outtakes on these pages, I understand better what catches my eye—and the role of my imagination and sense of humor—as I approach photographing my subjects.

## Into the Matrix

This image, oddly, was shot on the Blanko C16 film setting, which Hipstamatic describes as "subtle warm desaturations penetrate the colors." The reason I say "oddly" is that I don't often use that setting—but it worked very

▼ The iPhone is a perfect tool for experimenting and developing your personal vision. Get out and shoot a lot of images, then study your results and see if you can begin develop a better sense of your own style and personal approach to photography.

> "The key is to integrate our art into our life, not the other way around."
>
> – Brooks Jensen

successfully in this situation with fluorescent lights *(facing page)*. The yellow or green cast from the fluorescents was offset by the desaturation, so it recorded what my eye saw fairly accurately. I shot the final image with that film setting and the Lowy lens.

What my mind saw was a reference to the film *The Matrix*, where the characters leave the virtual world via land-line phones. I came across this scene at 4AM at the Van Nuys Flyaway bus terminal and I had to make some photographs before getting on the bus. After a little darkening of the curves in Filterstorm, I applied the Lo-Fi filter and sent the image to Instagram while I was still on the bus.

One of my favorite photographers, especially for his use of humor, is Elliott Erwitt. In my mind, at least, this image plays off his work and is something of a tribute. Ultimately,

the most important thing in this image is what is *not* there. Even for people who never saw the movie, I hope there is enough information in the image to make them wonder why the phone is hanging like that and where the person went.

## Volume

Something we don't talk much about as photographers is the volume of images it takes to make good pictures. At the time of writing this book I am close to shooting 7,000 images with my iPhone. That is what it took to get *sixty* publishable images for this project. Granted, some of those shots were just for fun, but that is the dedication to the craft that it takes to produce solid work.

# References and Resources

## Apps

1. iPhone Camera
2. Hipstamatic
3. Instagram
4. Filterstorm
5. Diptic
6. Squareready
7. Noir
8. AU Mobile
9. VSCO Cam
10. Lightroom Mobile
11. Sun Scout
12. Photoshop/Creative Cloud

## Books

Abell, Sam. *Sam Abell: The Photographic Life*. Rizzoli, 2002.

Arthus-Bertrand, Yann. *Earth from Above*. Harry N. Abrams, 2010.

Barthes, Roland. *Camera Lucida: Reflections on Photography*. Hill and Wang, 2010.

Bourne, Scott. *72 Essays on Photography*. Think Tap Learn, 2014.

*Galen Rowell: A Retrospective*. Editors of Sierra Club Books. Counterpoint, 2006.

Jensen, Brooks. *Letting Go of the Camera: Essays on Photography and the Creative Life*. LensWork Publishing, 2010.

Knisely, Matthew. *Framing Faith: From Camera to Pen, An Award-Winning Photojournalist Captures God in a Hurried World*. Thomas Nelson, 2014.

LaBelle, David. *The Great Picture Hunt 2: The Art and Ethics of Feature Picture Hunting*. Kernel Press, 1995.

McNally, Joe. *The Moment It Clicks: Photography Secrets from One of the World's Top Shooters*. New Riders, 2008.

Rand, Glenn. *Lighting and Photographing Transparent and Translucent Surfaces*. Amherst Media, 2009.

# Index